Dedication

*For Dr. Eleanor "Ranger" Hamilton,
who started making her mark in
education and sexual enhancement
before I was born.*

છ

*For my parents, Irv and Anne Blank,
born in 1902 and 1904 respectively,
who enjoyed sex with one another well into their eighties,
setting a great example for my generation
and for those which follow.*

Contents

v

Foreword

When I was a student, training to become a marriage counselor, I asked a lovely old lady in her late sixties, "When does sexual desire stop?"

Her immediate response was, "I'll let you know."

Her answer confirmed what I have known now for forty years; namely, that we are sexual beings from birth until death. Sexual energy is the source of our creativity; and would we be social beings without it? Over the years, many of my clients have told me that at the moment of orgasm they not only felt at-one with another human being, they also felt at-one with God. The orgasm reflex is our birthright and blesses our lives until we die.

Still Doing It is a brave offering from Joani Blank and Down There Press, who invite us to share the intimate and beautiful revelations of older men and women who have known "at-one-with" moments. These personal stories are not only sensitively and beautifully told, but also are often inspirational. They give us hope that as we age physically, we can grow wise in the art of creative sexual expression and garner the exquisite harvest of love teamed with sex. Maybe it takes seventy or eighty years to know how to harness hormones to create the exalting spiritual excursions experienced by elders, experiences we could barely imagine as young lovers.

As I read the stories in this remarkable book, I found myself alternatively weeping and laughing, moved and delighted,

and informed as I've never been by all the tomes on sex that it has been my lot to review in my professional capacity. The touching story of the author of "Lazarus," who at the age of seventy finally has the satisfaction of bringing the woman he loves to orgasm. "After a lifetime of frustration and disappointment," he writes, "I am getting all my sexual fantasies fulfilled. I find it hard to express how lucky I feel and how grateful I am."

It may be surprising to those of us conditioned to the idea that penile/vaginal sex is the only real sex, that almost all of these elderly couples mention oral sex as being more stimulating than intercourse, though they certainly do not eschew intercourse. One woman writes of the pleasure she gives her husband, "I appreciate now that the head of his penis is not just one big nerve, but a thousand little nerves, so that the tip of my tongue running across it leaves a comet-like trail of explosions." An appreciative man writes, "I'm counting on the idea that my penis won't stop until I do."

Again and again the writers note that their lovemaking is more a whole body experience than it is just genital activity. There are many descriptions of kisses and caresses awakening hitherto unexplored areas of their bodies to previously unimagined heights of ecstasy.

Readers of this eye-awakening book will find themselves discarding the antiquated, sex-negative notion that oldsters are not sexual. Such a notion has been especially dispiriting to those just entering their "golden years," and is totally false. Still, the uninitiated among us might assume that sexual energy will diminish appreciably in the later years. Not so for

many of these contributors. One man writes, "For me, a day without sex is no day at all!"

Of course, not everyone represented in this book exhibits such high energy levels, but many speak of enjoying sexual encounters several times a week, and almost all mention the sheer joy, if not necessity, of daily snuggling. A number of them have found that one delight of being retired from bread-winning occupations is that it opens up the option of daytime lovemaking.

The disproportionate numbers of women to men in their eighties has led many a widow in our homophobic culture to retreat into a kind of perpetual spinsterhood until she herself dies. This need not be. A few stories in this book illustrate what an enlivening love life a widow or widower may yet experience in their final years as they open their minds and hearts to the potential fulfillment of same sex love. One woman who never thought of herself as a lesbian, and had never "in her wildest imagination" dreamed of being involved with another woman, found herself experiencing "oceanic engulfment" with a woman lover with whom she subsequently spent many years as lover and best friend.

It is said of Oliver Wendell Holmes that one day when he was in his nineties, as he was walking down the street with a friend they spied a beautiful woman. "Oh," he exclaimed, "to be seventy again!"

Dr. Eleanor "Ranger" Hamilton

Introduction

In 1997, as I approached my sixtieth birthday, I started to wonder what people in their seventh, eighth and ninth decades were doing sexually. Stupid sex jokes, sarcastic comments and cynical statements aside, just about the only words I'd ever heard older women speak about sex were, "I'm too old for all that." Men didn't say much, but might occasionally suggest that they couldn't "get it up any more," and therefore were no longer "able" to have sex even if they wanted to. And heterosexual men in monogamous marriages or other committed relationships quite often said or implied that they'd like to continue being sexual, but that their wives or partners were no longer interested or willing.

Nonetheless, there were occasional intimations that an oldster was "still doing it." And I suspected that many more older folks were also doing one variety or another of "it" than the dearth of frank talk about sex would suggest.

I've been in the sex field long enough to know that very few people of any age, and virtually no one over sixty, talks openly and honestly about their sex lives, even, in many cases, to their beloved partners. But I know there is value in helping people start to talk about sex. And my experience suggests that once people get started, there's often no stopping them.

As I flipped through the few books available on the subject, I found that, for the most part, the content consisted of how-to's

for overcoming physical limitations that result from specific medical problems, as well as those associated with healthy though aging bodies and body image concerns. Societal norms tell us that older people, especially *really* old people, are not sexual creatures. But none of these volumes asks older people simply to tell us about what they do and how it feels to them. In fact, the tone of many of these books is one of grim determination, exhorting the elderly to keep going or start again.

Throughout my career, when I've recommended that an older person try to start talking about sex a little, I've repeatedly heard the lament, "Nobody in my family talked about sex when I was growing up." I usually respond that hardly anyone grew up in a household where family members talked about sex, no matter how liberal or conservative that family may have been, and no matter during which decade they were growing up.

Why is this? Although our culture has generally moved well beyond the ethic of sex-for-procreation-only, a significant portion of our population still looks askance at sexual couplings between people who are well beyond their reproductive years, often even casting a critical eye on the continuation of solo-sexuality into the later years. So those who talk about sex risk the criticism of those around them for going against the norm.

Another cultural bias that leaves many elders feeling like their sexual options are extremely limited is our idea that sex equals intercourse, that only intercourse really "counts" as sex. Far too many men and women are still committed to that idea. If their bodies will no longer cooperate in producing the

physiological changes required for penis-in-vagina intercourse, then they feel that all sexual activity should cease.

I don't expect that the stories in this book will necessarily convince huge numbers of older readers who are not currently sexually active to suddenly get busy in the bedroom, especially if they have not masturbated or had partnered sex for many years. Rather, I'm hoping that these stories will help oldsters who are still sexually active to realize that they are far from alone, and that others in their age group are engaging in as great a variety of sexual practices as are their younger counterparts. In fact, many, if not most of these contributors are "doing it" more, doing more and different things and enjoying it more—in some cases a great deal more—than they did in their younger years.

I am also eager that readers in their twenties, thirties and forties will more become more accepting of the sexuality of those in their parents' generation, particularly that of their own parents and other older family members. Almost no one can imagine his or her own parents being sexual at any age, but it is important that younger adults remember to treat their parents' desire for privacy, excitement about a new "boyfriend" or "girlfriend," a decision to remarry, or to live with a lover with respect. Older parents don't want their adult kids meddling in their love lives any more than teenagers want their parents interfering in theirs.

Most of all, I hope that this book is useful and encouraging to those in their forties and fifties who are often acutely sensitive to diminishing sexual interest. This group includes those separated or divorced after sometimes lengthy marriages or

relationships; those whose sexual problems have been getting worse so gradually they didn't realize it was happening; men who used to be able to take an occasional erection failure in stride but can no longer do so; women whose desire and sexual interest hasn't returned after their children are grown as they had hoped it would; and those so stressed by busy careers and lives that sex has all but disappeared from their daily lives. I also hope this book will speak to middle-aged readers who would describe their current sex lives as happy, to assure them that things do not inevitably get worse with age—indeed sex may get a whole lot better.

In the original call for submissions for *Still Doing It,* I told potential contributors that they might wish to write about how they had overcome obstacles to fully enjoying their sexuality. Several of the men have written about specific physical limitations, medical problems and erection failures. Both men and women write in some of these stories about overcoming years of loveless and/or sexless marriages, or involuntary celibacy. But mostly these stories describe what does work, not what doesn't.

As we age, we all face natural changes in our bodies, ageist anti-sexual attitudes in the world around us, and the deterioration of sexual self-confidence that can result from these attitudes. The people who've written stories for this book manage to have a good time despite these obstacles. Some people who are now over sixty had the good fortune to be younger adults during the sexual opening-up that we experienced in the late '60s and '70s, and they have no intention of stopping, or even slowing down. Even for those who were

older at the dawn of the '70s, more relaxed attitudes toward sex have been beneficial.

During my twenty-plus years in this work, and especially looking back further into the '50s when I was in high school and college, I've seen significant improvements in our attitudes toward sexuality, specifically as they relate to older people. For instance, as older people become more independent they are more willing to engage in sexual activity, with or without the approval of their adult children. Older parents are increasingly less likely to live in the same house, neighborhood, city or even state as their children or other younger relatives, so they can more readily do as they please out from under their children's watchful eyes.

Secondly, the overall health of older people continues to improve. We are more attentive to our diets, we exercise more, we stay informed about the world around us. In sum, we take care of ourselves altogether better than seniors did even one generation ago. Being healthy increases the likelihood that we will be having sex, and being sexually active undoubtedly helps us live longer in good health.

Physicians and other health professionals are slowly but surely becoming more aware of sexual issues that may be raised by their patients, as well as being more informed about the sexual effects of medical conditions. Even if they don't ask their patients questions about sexual changes associated with health problems, they may at least volunteer information, for instance about the side effects of medications, or about when it is safe to resume sexual activity after surgery or illness. In addition, drug testing is now more likely than in past decades

to include consideration of the sexual side effects of any new treatment.

In cases where health professionals fail to volunteer such information about sexuality, which still happens far too often, it is fervently to be wished that they will at least be receptive and responsive to direct questions about sexuality from their older patients (as well as those who are younger). Of all helping professionals, physicians are perhaps the most likely to be asked questions about sex and the least likely to know the answers. In the '70s there was a slight increase in the number of medical schools that offered even limited sex education to their students. I understand that now many of these courses are no longer offered.

It has long been known that people who become clinically depressed typically lose interest in sex. In fact, depression of any severity takes its toll on libido in both men and women. The new generation of anti-depressants are markedly more effective in treating depression than were the older medications, and they have significantly fewer side effects. Unfortunately, one prevalent side effect of some of the newer drugs is that they can inhibit sexual arousal and/or orgasm. So, ironically, at the same time that one's anxiety decreases and one's heart and mind open to new sexual possibilities, one's body may become less responsive. Most people I know who are taking these medications while in an ongoing sexual relationship, however, are happy to trade off some of the sexual heat they remember from past years for the relief of debilitating depression symptoms that had made it virtually impossible for them to connect intimately with their loved one(s).

There has been a slight but noticeable improvement in the way that the media treat the sexuality of older persons. Sure, jokes about elder sex, some of them especially cruel, still abound. But every once in a while a film, TV drama or sitcom acknowledges the sexuality of older characters in a fairly matter of fact way. It always comes as an especially pleasant surprise when it is at least implied (even though never depicted) that an older couple's sexual activity isn't limited to affectionate glances, embraces and snuggling.

No story in this book mentions Viagra, because most of these stories were collected before Viagra became an overnight sensation. As valuable as Viagra has proven for many men with serious erectile dysfunction, I am concerned that its widespread popularity suggests that both men and women are still firmly in the grip of the intercourse bias. The public's passion for this "wonderdrug" implies that it's more important to be able to "perform" intercourse, than it is to give and receive sexual pleasure.

To be sure, some of the male contributors to this book may have by now started to use Viagra, but their essays tell happy pre-Viagra stories of fulfilling sex that is only rarely dependent on firm and 100% reliable erections. It won't be long before we'll see pharmaceutical "cures" for female sexual dysfunction becoming available, and it is likely—and in my mind somewhat unfortunate—that they too will gain popularity more because they facilitate intercourse than because they enhance a variety of sexual interactions.

I am, as always, appreciative of the fine editorial hand of Marcy Sheiner, which brought life and focus to these stories.

Introduction

When we were doing the photo shoot that produced the image you see on the cover of this book, I posed our models (good friends but not regular sexual partners) snuggling, laughing and gazing into one another's eyes. But it wasn't until photographer Michael Rosen and I said, "Oh, just go ahead and do whatever turns you on," that we were able to capture the real exchange of sexual energy that you see in the photo we finally selected.

I hope that this sense of energy exchange, liveliness, playfulness and heat comes across in the words of these stories as well.

<div align="right">

Joani Blank
Oakland, California
January 2000

</div>

Twilight with Leo

❦

Louise Meadows

I live in an enchanted world with Leo. It's true things are a little dimmer than when we first knew each other. We don't hear as well, see as well, or get around as quickly at age seventy-one. But how alive to each other we are, considering we're in our twilight years.

Today we got up late as usual. It was almost noon. An hour earlier he had moved toward my side of the bed where I was curled up facing away from him. As soon as I felt his hard body pressing against me, one hand manipulating my nipples until they were stony-erect and the other fingering my ass, I began to lubricate in expectation of the good time, the hard time he was about to give me as he murmured hot fantasy into my ear. Afterward he told me what a "bad lady" I was to cause him to shoot his load of semen into me. We've been together for three years and I'm as in love with him as I was when I was sixteen. Yes, our sexual history goes back that far.

I wrote this note to him in early January 1997, while I was still living in California.

Every night your voice opens me up and after the phone call I lie sleepless for hours in an agony of unsatisfied desire. Darling Leo, I wouldn't let you do this to me forty-nine years

ago. Is that why you're doing it now with such a vengeance, grinding me down, making me weak and helpless with your low, rough voice? Your voice is my damnation and my redemption.

I was in San Francisco and Leo was calling me every midnight from New Jersey. Each time we talked for three to four hours. My hips got sore from writhing on the bed in ecstasy, as he talked dirty to me. It was like being in my teens again, only better.

I remember my last date with Leo, going up the Hudson on a boat ride in 1947. By then, we were out of high school where we had once gone steady for a few months, and living in different worlds. Leo was making his way in the corporate world and I was commuting to Barnard College in Manhattan. We hadn't seen each other in a couple of years. It was dark and quiet along the river as the ferry moved over the water north to Bear Mountain. There were pockets of noise on the upper deck where a band played. Leo and I danced there for a while but there was a tension between us that I didn't understand. Leo was silent and tense, seeming to be sharply aware of me and at the same time lost in disquieting thoughts. After a short while we left the dance floor and sat below decks by the rail, watching the eastern and western shores float by. I sat on his lap as he kissed and caressed me.

Later in the car, his fingers went deeper, bringing me unexpectedly to a peak that both startled and shamed me. I fervently hoped he hadn't guessed that he'd just brought me off. Nice young ladies weren't supposed to allow such things to happen to them. When he suggested we go further, I told him I

couldn't have sex with him since I didn't love him. He had no way of knowing I was in love with Don, a deeply troubled young man who had initially asked me to marry him and then broken the engagement. I still hoped we could make it together and if I was saving myself for anyone, it was for Don.

My rejection of Leo made him sore. As he left me at the door, he'd muttered, "I didn't know you were that kind of girl." In the grip of 1940s sexual mores, I thought he was scolding me for letting him go as far as he did. I didn't know until recently that, stung by my rejection, he was accusing me of teasing him, with no intention of going all the way.

We first met in high school where Leo sat in front of me in English class. We began to talk, Leo in devastating profile, Leo charming and witty, laughing at my jokes or his. I fell in love with him. He was a brainy and talented figure, exuding sexual confidence beyond his years. I learned later he'd lost his virginity at age twelve.

We began dating, riding to the movies or parties or to New Jersey roadhouses in his family's 1939 maroon Packard convertible, Leo's thigh somehow always interjecting itself between mine as he whirled me around on the dance floor. The rhumba was our favorite. I loved the spicy fragrance of Leo's herringbone jacket. Later, on my front porch, he kissed me, absorbing my mouth into his in a way I had never experienced before; this kiss haunted me for years.

But while I was concentrating on Leo, yearning for him, fearing I wouldn't be able to resist his advances, he was seeing other girls. When he started dating Dorothy, the pretty, popular vice-president of our junior class, my heart turned hard

toward him, even though I'd never had any real claim on him. All I thought of was getting even. The following year Leo received an appointment to Annapolis and attended a private school to prepare for it. He knew I was still angry about Dorothy and he wrote me a long letter of apology. I made sure Dorothy got to read the letter when I passed it around our cafeteria table next day. Then Leo called me for a date. My mother, uncannily sensing when I was "dangerously" in love with a boy, and fearing, as she said, that I would be caught in my own web of revenge, refused to let me go out with Leo.

Two years passed. Leo called me and asked me out again, to the night ride up the Hudson. In the interim he had served a stint in the Navy, entered Annapolis and dropped out again, and was working as an NBC page in New York. By that time I'd been in love with Don for almost a year, although there was little chance our sporadic affair would end in marriage. The touch of Leo's hand had inflamed me but I didn't trust him, figuring I was one of many. When he phoned me for a date a year later, I turned him down again, still not trusting him.

In 1949 I became pregnant and married my baby's father, a man with whom I wasn't sexually compatible. We had three children and settled in Northern California. Over the intervening years, I thought of Leo occasionally. His inimitable kiss, his hands on my body gently compelling me, his fingers at my clit bringing me to instant orgasm. But that seemed a lost time of youth and excitement. The memory of Leo grew dim.

In 1989 my husband and I had made a trip back to New York. We visited my old schools in New Jersey, including Teaneck High School. The memories this evoked (as well as

watching the movie "Dirty Dancing" several times!) began to turn me on sexually. I was determined to set the wheels in motion that would produce a forty-fifth reunion. I'd been sexually deprived long enough and I blamed myself for this. In my heart I knew I was setting the stage for finding a new mate, and I knew it had to be someone who had made a deep impression on me in my youth. It had to be exciting, yet familiar, as though the remembered familiarity was what actually made it exciting. I wondered if I'd see Leo again.

We came together again for the first time in forty-three years at a dinner party the night before the reunion banquet. I was thrilled to see him and we took up where we had left off in 1947. It seemed so right and natural to be sitting next to him on the sofa, exchanging the stories of our lives since our Hudson River excursion. I was thinking, I'd love to give our relationship another chance but how can this happen when we're both married and separated by a continent?

The forty-fifth reunion had been so successful that the fiftieth was planned for October 1995. I was divorced by then, but somehow I didn't have the heart to attend. However, I found out Teaneck High School was putting out an alumni directory and I ordered a copy.

In the meantime, Leo had been trying to reach me at the only number he had for me, a disconnected one, hoping I'd be coming to the reunion. In January I received a copy of the alumni directory. Leo's name was listed. The entry showed that his wife was deceased. I wrote to him immediately, suggesting we get together.

He called me minutes after he received my letter. As soon

as I heard his voice I was sixteen all over again, but a mature sixteen, talking to the man I loved. We wanted to be together immediately. We talked to each for three or four hours every night for the next month. A lot of it was sex talk. We talked about what we would do with each other when we got together. When I described how I masturbated by grasping my labia with both forefingers, he laughingly asked if there was room for his tongue in there. We were on fire. I walked around with perpetually drenched panties. We wanted each other physically, mentally and emotionally. We couldn't wait any longer. With my children's help and enthusiastic blessing, I packed up my apartment and flew East to live with Leo.

I'll never forget the state of high excitement I was in on that cold February day as the taxi Leo had ordered brought me from the airport to his house. I glimpsed him watching anxiously from the front window as the cab pulled into the driveway. All those years wasted, I noted sadly, when we could have been together. But these thoughts quickly evaporated as he led me into the house. I sat on the love seat and he kneeled before me, holding my hips with both hands and resting his head against my chest as I put my arms around his neck. Later in bed, I looked down into his face and saw the boy of sixteen I'd been in love with. I was in love all over again.

What's it like to be reunited with a lover after almost half a century? It feels like going home. There's a bitter sweetness to living a few miles from the town where we grew up and knew each other. Every week we drive into Teaneck and eat lunch at the same ice cream parlor where we used to enjoy hot fudge sundaes together as teenagers. On warm summer evenings,

we sit on the lawn of the high school campus. With our year-books on our laps, we stare up at the brick and concrete facade of the gothic castle on the hill where we first felt the pangs of burgeoning sexuality. Recently we toured the building and visited the rooms where we had studied music and math and Latin. These memories sanctify our passion.

Reuniting with Leo after all this time means that I have finally realized my sexuality. I feel that all the other attempts to find the perfect lover were a waste of time. At first, we both suffered profound feelings of regret and remorse that we had endured forty-three years of unpleasant marriages before getting together again. But now, we have simply accepted what happened to us and cherish our bliss. The insights about sex and emotional relationships that I've gained have been phenomenal. I see how men are aroused quickly through visual stimulation, while women need to be slowly aroused through touch and verbal suggestion. My orgasms last longer than Leo's and I experience hours of afterglow following the sex act during which I love to fondle Leo's body. Ironically, even though we're not legally married (for financial reasons), I now know the meaning of "married love."

Looking back, I realize that while I felt comfortable with Leo years ago, talking and joking in the classroom, there was also a lot of anger between us that I now see was an ingredient of our sexual passion. My emotions as a teenager were more romantic than erotic. When Leo tried to rub my belly in a darkened movie theater, I was more alarmed than aroused, because of his insistence and the experienced way in which he was handling me. I had to push his hands away sev-

eral times, puzzled that he would even attempt such intimacy. Jealousy and possessiveness were my primary emotions (they're still lurking there). My sharpest and most painful image is of Leo looking smug and happy as he followed Dorothy out of the classroom. She'd gotten a friend to tell Leo she wanted to go out with him.

I see now that our initial relationship was just a suggestion of things to come. Only our combined years of experience plus the original physical attraction has made this present relationship possible. Our real life together is much more complex than a teenage sex fantasy. We nurture and support each other in every way possible. Just from talking to Leo on the phone I knew our relationship was going to go way beyond the fantasy. However, in my fantasies of domination and submission, Leo is still the prototypical demanding male. As he manipulates my pussy to prepare me for penetration, I create a scenario of punishment in which he is a young man in his twenties inducing me, a naive teenager, to submit to his sexual demands. Although I no longer have a kind of sexual seizure every time I look at him, as I did when I arrived here three years ago, he marvels that I am always open and receptive to him.

Soon after reuniting with Leo, I realized that he perfectly matched the image of the nameless, faceless lover I'd been fantasizing about all the years of my marriage. Leo's sexuality fits together with mine as smoothly as the joined pieces of a jigsaw puzzle. I look back with compassion at the pathetic frustrated lady I was, continuously engaging in abortive affairs during my long, unsatisfying marriage, ever in search of

a compatible lover.

I'm convinced elderly lovers have the best of it. We know our time is limited, one or the other could die at any time, so there's a greater urgency about sex. Leo is a heart patient, though he's able to work two days a week, and this makes our time together all the more precious. We are no longer encumbered with heavy family responsibilities so we can devote our entire attention to pleasuring one another.

There was always a powerful physical attraction between us, so we've simply taken up where we left off half a century ago. We both have powerful libidos. I had my first sexual encounter when I was four and began masturbating at five. Leo played doctor with the daughter of family friends while he was growing up. When she presented him with a condom stolen from her father's night table, their childish groping culminated in full-blown intercourse when he was just twelve years old.

Leo keeps a photograph of me at age seven on his night table. Sometimes after we make love, he studies the innocent profile and invokes the spirit of my mother. "Forgive her, Mrs. Meadows. She doesn't know what she's doing."

We make love all over the place; in the pool, in the bathroom, in the living room, in the bedroom. I suck his penis frequently as much for my pleasure as for his. This is something I never did for my husband. I love it when Leo straddles me on his knees and drives his cock into my mouth. It makes me juice up just to feel it filling my mouth, going down my throat. I love the taste of his semen as it spills across my tongue.

Although our mildly handicapping infirmities prevent us from any super-athletic activities, we are able to accommodate each other satisfactorily. In bed, Leo turns on his side and, with my legs high in the air, enters me sideways. Or we do it doggy style, sometimes on the bathroom floor after a shower. In summer we fuck in the downstairs lavatory after a long swim in the pool. After years of being chaste, I experienced a few muscle pains in my hips getting used to these new positions but now I feel stronger than ever. And, of course, my many years of hormone therapy help with the underpinnings of physical passion, making me wet and ready as soon as Leo puts his hands on me.

Every inch of his body is erotic to me. Leo is very physical, constantly hugging me, grabbing me from behind, kissing my neck, squeezing my breasts, holding my hand. In the shower, the heat and steam and my mouth around his cock-head either bring him to climax or prepare him for the fuck session that follows. We go to bed at midnight and watch porn videos ("training films," as Leo calls them) in our "love nest" under the eaves until two or three in the morning. It's a teenage fantasy come true: up all night having fun, then sleeping till noon. These are the happiest, sexiest days of our lives.

Through the Jungle

❧

Doug Campbell

I am eighty-one years old, and for much of my life I have been finding or trying to find right and healthy pathways through the jungle of human sexual practices and attitudes. When I was thirteen I promised God that I wouldn't masturbate again. But gradually I persuaded myself that pleasure-touching without orgasm wouldn't be so bad. Then I decided that pleasuring myself up to the brink of orgasm was okay, even if I then enjoyed the "involuntary" dynamic of my genitals taking over and producing a climax without any final effort from my hand. When I finally acknowledged that I was undeniably cheating on my promise, I noticed that God didn't strike me with lightning.

When I was about seventy, a long-time woman friend and lover a few years younger than I was dying of advanced abdominal cancer. She and her husband welcomed my occasional visits. One evening as I spent a long time feeding her spoonful after spoonful of the herbal drink that had become her only food, I spoke to her of the feeding process as "safe kissing," acknowledging how lovingly I was applying the spoon to her lips. Later that night, her husband awakened me to say that she had died in her sleep. He showed me that she

had passed away with a finger on each side of her clitoris.

I have been reading a lot in the sex stories newsgroups on the Internet. I have accumulated a collection of stories I consider turn-ons, mostly experiences or fantasies that feel real. I enjoy reading these stories, but Mary, my seventy-five-year-old wife of fifty-two years, doesn't want to read my selections.

About ten years ago I had prostate cancer, and after radiation treatment I lost the ability to have erections. For some time Mary and I made do appreciatively and effectively, but about five years ago we decided I should get a penile prosthesis, two flexible rods inserted in the penis on either side of the urethra. The rods are designed to be straight and stiff when that's wanted, but to bend if the owner wants the penis to point down. I keep the penis pointing up, inside an athletic supporter, though I was afraid for awhile that the bulge would be too conspicuous. I'm conscious of the bulge sometimes when I hug, but have persuaded myself that it's not too noticeable.

Mary and I have intercourse about once a week, though I am ready for more, and we enjoy hugs and kisses, and bareskin touches at bedtime. Mary doesn't breathe through her nose easily, so we have to kiss briefly without stopping her breathing. This breathing difficulty has prevented her from actually sucking on my penis, too, but when we're in sixty-nine position her lips and tongue can still be very effective while my tongue enjoys her.

We live in a cold climate and wear lots of warm clothes. We keep our bedroom cool, but pre-warm the bed with an electric blanket so we can sleep nude. Most nights we don't

get to bed until Mary has finished all her reading or book-keeping or chores and is ready for sleep, but I am very aware of her nakedness and usually, after stroking other parts of her body, my hands approach her crotch. I love the times when she actively welcomes the touches. Then she guides my hand to her vulva; I am especially pleased when she actively holds or strokes my penis as well. Sometimes Mary turns in the bed for a sixty-nine warmup. Ideally, we continue until she has an orgasm, and then she wants penetration. But often she acknowledges my readiness and invites penetration before she has come. After I have slid my penis in and around for awhile, and especially if I have had an intensity-of-feeling-which-might-be-an-orgasm, Mary is often ready for my finger stimulation and an orgasm; sometimes she's just ready to rest.

Most important, we love each other and still love doing it.

Staying Alive

ಌ

Beth Hartman

When you are young, sixty sounds very old—sixty means Social Security, arthritis, slowing down, and sex nothing like it used to be, if at all. Well, I want to let you know that what you have to look forward to may be a lot better than you think.

I would not go so far as to say that sex got better as I got older, but it did change. At thirty-nine I had a total hysterectomy, which was the worst thing that had ever happened to me. But after I got over the trauma, the meaning of sex shifted: It became a beautiful form of expression, and *joie de vivre*, as well as my greatest pleasure. I can't live happily without it.

I am sixty-three, a professional, a grandmother, an active church-member, single, and yes, I am still doing it. Next to my family, love/sex is the most important thing in my life. After being divorced twenty years ago, it took me a while to realize that sex was the reason I ended or didn't end relationships. I have had a lot of them. To me sex is heaven on earth, God's reward for the difficult things in our lives. Sex is the real reason that I jog, work out, gulp down vitamins; all this I do in order to be, pardon the expression, fuckable.

The most unbelievably wonderful sexual relationship of my life began when I was fifty-one and ended when I was sixty-two. Steven was nineteen years younger than I and married. During those nine years I tried repeatedly to get out of the relationship, became engaged to three other guys, but always ended up back with him. What held Steven and me together all that time was beautiful sex, an ecstatic blend of the physical and spiritual—it was worship. Sex between us had nothing to do with technique—it all came from within. I did things with him I had never done with anyone else. It was transcendent, something beautiful we created together.

Right now I'm in a monogamous relationship with a wonderful man who is eighteen years younger than I. I feel bad sometimes about the age gap, but I'm happy with him. As I write this I look up at a yellowed paper on my bulletin board on which I once copied these lines from a poem by Ezra Pound:

Life gives us two minutes, two seasons—
One to be dull in;
Two deaths—and to stop loving and being lovable,
That is the real death.
The other is little beside it.
I believe that's true, and I'm committed to staying alive.

Lazarus

❧

Bill Noble

When I died, sex stopped.

Perhaps both parts of that sentence need a little explaining. A year and a half ago, I had a massive heart attack. Two days later, in the wee hours of morning in Intensive Care, my heart stopped—and a noisy gaggle of doctors, nurses, and paramedics restarted it (and me) some four minutes later. That's the first part of the sentence.

The second part is more complicated. Spending days pumped full of morphine was wonderfully disinhibiting. I sang dirty songs, told long ribald stories, and lovingly and poetically complimented every woman who came into the hospital room on the transcendent beauty of her breasts (nurses are very long-suffering). I had rambling, ecstatic conversations with my wife about sex, fantasy after feverish fantasy, each more ambitious and preposterous than the last.

But physically, sex stopped. The drive simply ceased to inhabit my body.

For weeks, my penis was only an odd appendage, useless except for aiming, with great labor, into pee bottles. It was utterly indifferent to any external or internal stimulation.

At home, as my strength slowly returned, I experimented.

I wanted to be turned on again. I had a deep desire to have a hard cock. Stroking it, rubbing it, waggling it limply back and forth —all accomplished exactly nothing. It remained an inconsequential rubbery dangle, absent of sensation or response. I wondered if this was to be a permanent part of my post-infarctive existence, but still, I was so gloriously happy to be alive and back home with my family that a wilted willie was a remote concern. I had returned from the dead—most of me, anyway—cosmically happy, transported with joy by the birds outside my window, going suddenly teary every time my children drifted into view or came for a good-night kiss.

I slept in the living room because I couldn't negotiate the stairs to the bedroom. The big double bed in the living room—our hospitable Polynesian *hiki'ai*—was my home. Eventually, my world expanded to include shuffling voyages to the bathroom and occasional meals at the table with my wife and our two children. It was a big event when I graduated to visitors and to daily walks the full length of the house.

Our erotic life had always been exuberant. Since childhood, sex had been an ocean I swam in; my wife and I shared an intensity of appetite. Lovemaking, we affirmed again and again over our decades together, was what we grownups did for play. A huge mirror dominated our bedroom; our "toy drawer" was always full and well-used; we favored friends who were playful and outspoken sexually. Now, where there had been exuberance, there was silence.

One afternoon a dear friend came to visit. She sat on the couch across the room and we talked about life and death. After a while, she moved the conversation to teasing erotic

banter, something that had always been a delicious part of our friendship. The kids chattered in the other room. My wife worked away in her office just off the living room, chiming in occasionally with a ribald remark.

Suddenly I realized an unmistakable burgeoning was taking place down under the covers, accompanied by swelling pulses of arousal. I grew half-hard. I was amazed!

"Jan," I grinned, "you've given me my first hard-on in a month. Half a hard-on, actually," I added, grinning even more broadly. I felt excited and scared. I also felt uncertain of whether I'd overstepped the bounds of propriety, but Jan smiled too, blushed, and congratulated me. The three of us (my spouse, looking remarkably pleased, had come in and joined the welcome party) celebrated my newly-revenant wiener for a few minutes, and then our talk and my internal state drifted toward other topics.

For a week and a half nothing else happened. No other spontaneous arousal manifested itself; my cautious experiments and contrived fantasies produced no results. My wife was attentive and affectionate but avoided anything remotely sexual; she was as leery as I. Would I turn toes-up the first time we made love? Could my severely damaged and still unstable heart handle it? Despite the tremendous love and affection we were both feeling, we had an unspoken agreement to leave sex off our list. The possibility of my emitting a strangled squawk and falling over dead was a less-than-perfect aphrodisiac.

On the next visit to the hospital, we brought up the subject of sex with the sparkly nurse-practitioner who was our chief

advisor. Could we make love, did she think? "Whenever you feel you're ready," she answered with a salacious twinkle. And then, in the same low-key affectionate way, she added a few sensible-sounding cautions about not holding my breath and pushing up my blood pressure, about not "overdoing it" the first few times. Though it certainly wasn't what she had intended, in my mind I squawked and flopped dead again.

One sunny winter morning, I lay propped up on pillows on the *hiki'ai*, reading. I set the book down as my wife sat beside me. We "went all mooshy," as my ten-year-old daughter liked to say, mooning at each other. We looked deep into each other, our eyes watering with a sudden onset of emotion: here we were, alive. The look went on and on—lucky for us the kids were at school or they would've teased us mercilessly.

My wife leaned forward and kissed me. At first the kiss was gentle and speculative, but then the novelty of this first overtly sexual kiss overtook us; tongues crept out and lips became more gymnastic; breathing accelerated; hands moved up and began to trace the planes of faces. For a long time we were content to simply kiss. I was lost in the sensations, filled with tremulous delight but no deeper stirring. Arousal still felt dangerous.

She pulled back, took my face between her hands and brushed her lips over each of my eyelids. When I fluttered my eyes open again, I saw new intention forming behind her gentle gaze. She began to open her shirt, button by button, holding my eyes. She dropped the shirt to the floor. Her pale camisole came next, over her head and onto the floor in a single movement. Then her pants, panties tangled with them:

She squirmed them over her hips and kicked free. She sat naked on the edge of the bed, breathing deeply.

With ceremonial gentleness, she folded the covers down, still holding my gaze. She unbuttoned my shirt—all I was wearing—pulled it away from my arms, dropped it beside her own jumbled clothes. I balanced on a knife-edge between turn-on and fear. I felt self-conscious about my body: the hospital reek, the shaved patches on my chest and legs where electrodes had been attached, the aura of inactivity and weakness. She eased me back on the pillows. Not a word was spoken; I lay exposed to the winter light flooding through the windows.

She climbed onto the bed beside me. On hands and knees, she began to kiss. She kissed my forehead and temples, her eyes open, her breathing gentle and relaxed. She kissed my face with intricate attention, and then my neck. Her lips lingered over the pulse in my neck.

Then she explored my chest and shoulders. Her breath, moving over my nipple, sent a shiver the length of my body, but the overriding reaction to her patient nurture was a feeling of immense safety and calm, as fear leaked slowly out of me. She grazed over my belly and sides, nuzzled into my navel, playing a little, then resuming the small kisses again. From time to time, she'd gaze up over the curve of my chest into my eyes, then go languidly back to kissing. I relaxed more and more.

She nuzzled into my pubic hair, murmuring, "I love your smell . . ." and left soft kisses on my penis and scrotum, here, and here, and here. She continued down my thighs, drawing

my legs gently apart so that she could kiss everywhere. Knees. Lower legs. Feet. Kisses planted sweetly under each arch. Kisses brushing each toe.

Another long languorous look, and she laid my arm down along my side to roll me over. Kisses behind my ears and under the nape of my neck. A whole geography of kisses over my back, a warm cheek lying for a long moment between my shoulder blades. Kisses that barely brushed the fuzz over my buttocks, warm breath here and there in the deep place between them, and then kisses trailing down the back of my legs. Playful little kisses flirted from the back of one knee to the other and back again.

She rolled me back over. This time her kisses focused on my belly and inner thighs. My scrotum lifted and tightened, slowly, sleepily, without alarm. Her eyes returned to mine, asking permission. My peacefulness, my lack of a "no" was answer enough. She bowed her head and I felt a sudden wet warmth as she took my small, unresisting penis inside her mouth. Her head lay against my thigh, just above the slowly-healing incision the doctors had made in the great artery there. Her hands drifted over me, caressing, speaking quietly about our love, about the lack of agenda or urgency. A vast liquid jubilance swirled from her circling tongue the whole length of my body. I felt like a bowl brimming over with pleasure.

It never occurred to me to wonder if my cock would harden. I swam in, submerged in a starry voluptuousness that needed no steering, no direction. Returned from death, I was now fully reentering the world.

My wife's patience was endless. She had no more need than I did for any goal beyond this welcoming, but after a long time I realized, mostly from changes in the way she moved, that I was getting hard. The pleasure changed: It became electric.

I propped my head up on the pillow and looked down. Her long, shining hair veiled her face. My cock was a thick brown column that disappeared into her wide-open mouth. I felt a tightening of my stomach muscles, saw the muscles in my legs bunch. A sweet surge rolled through me. She parted her hair with a graceful hand and looked up at me. Her eyes shone. I lay, overwhelmed with sensation. My cock seemed suddenly huge and vital. I have never felt so loved, so cared for, never been filled with such a tumble of feelings for this woman with whom I have lived for a quarter-century. A deep sigh welled up and came out of me. She rose and straddled me. Her hair, unbound, swept over my face and chest, and I shuddered again. She raised herself and pushed her pelvis forward, parting her lips so I could witness her arousal. She glistened, coral-pink, intricate. She took me in her hand and guided me into her. Slowly, she lowered herself and began a gentle, rhythmic thrusting, eyes locked with mine. We were exalted and peaceful all at once. We shared two bodies, one pleasure, one sure chord between us, reveling in this renewal. We breathed as one. Our hearts beat steady and sure, loud in our ears. The winter sun danced over the new green of the hills. In this quiet corner of the world, for this day if no other, for these two frail creatures bound together on their journey, death had no dominion.

Youth is Wasted on the Young

❦

Anne Aiello

Until my mid-fifties when I met Tony, my sex life was pretty dormant. What there had been of it, with my long-time husband, had been boring and, thankfully, infrequent.

The first time Tony and I had intercourse, I had the most crashing and powerful orgasm of my life. Nothing I had ever experienced with my husband compared to it. And when he came inside of me I thought I would literally melt. I felt completely loved. After this I could think of nothing else. I fell in love with love and with sex and with sexual pleasure.

Tony introduced me to one fascinating sexual treat after another. He likes to alternate "regular" sex with "fun and games" sex, as he calls it. He has a very imaginative mind and enjoys thinking up "scenes" for us to play. He really likes my body, especially when I'm dressed in sexy black lingerie. When we're engaged in one of his scenes, garter belt, nylons and heels are a must. Open-cup bras that lift my breasts and allow him to play with my nipples are also a favorite. Open-breasted bustiers, or waist cinchers, with attached garter belts are also good outfits.

At first I felt a bit silly dressed in these outfits. After all, this stuff went out in the '50s when good old panty hose were introduced. However, my perspective changed once I saw the

effect these outfits had on Tony. I even discovered that I'm an exhibitionist! I began to *like* the way I looked in these sexy outfits, and I especially liked seeing the erection he got when he saw me dressed this way. Not only that, I began to feel powerful in my new outfits. It's a nice feeling to have that kind of power over a man—to arouse and tease him with your looks. First I looked sexy and erotic, then I began to feel sexy and erotic, and then I really *was* sexy and erotic.

I had never experienced oral sex before, though I'd read and heard a lot about it. I discovered I liked it a lot. Tony's tongue and lips on my clit and pussy are an incredible turn-on. He nibbles and sucks in the most delicious ways. When he alternates this nibbling and sucking between my nipples and clit I usually come very quickly. I also like to give him blow-jobs. With his guidance, I've learned some good techniques, and now take pride in my ability to drive him to distraction. The only thing I can't accommodate is anal sex. It turns me off completely and even frightens me. I don't know why, but it does. He's a good sport about this and he backed off when I told him anal play was out of bounds. I do like to fuck him in the ass, though. Surprise! One of my female friends told me that it was a power trip on my part. I don't know if that's true, but I like doing it. The gender role reversal is a real turn-on for both of us and I get very horny. There have been times when I've been fucking him where I've lost complete control and have allowed myself to soar into sexual heaven. It's a feeling that is hard to describe, a sense of true freedom.

Early on Tony confided in me his interest in B&D (bondage

and discipline) play, especially bondage. This "confession" was not intended to put pressure on me, but was a revelation about his sexual past and interests. At first, the idea of B&D play was a turn-off. Who would want to give or receive pain during sex? It seemed counterintuitive. But since it he felt so strongly about it I decided to try it. He showed me the pleasure/pain things he liked, especially nipple clips. He likes to have his nipples bound with tweezer-type clips or clothespins. He tried them on me but all I experienced was pain—definitely not pleasurable pain. Just as with anal sex, I was turned off and frightened. Not him, though. I didn't understand it, and still don't . . . but different strokes for different folks. If he gets off on this and I can provide him this pleasure, why not?

It would have been interesting, and probably hilarious, to have a videotape of our early B&D sessions. They were anything but sexy: all instruction on his part and all learning on mine.

"Do this."

"Why?"

"Never mind why, just do it!"

"I really want to know why."

"Damn it, just do it and you'll find out why."

"What if I don't? I have to know why I'm doing something so that I don't hurt you."

"I don't care if you hurt me, in fact that's the point!"

We both broke up laughing more than once. I've learned from this that it is possible to achieve everything you want with your sexual partner if you have the patience and desire

to hang in there, and the willingness to communicate.

Eventually I learned that I am a domina at heart and that I am good at this role. Very good. I like to "torture" him and tease him mercilessly. It is so much fun to tie him up (which he loves), to bring him to the brink of coming and then back off. Again. And again. And again. Mean. Delicious. I find that the best thing is not to have a script, but to let the mood dictate whatever happens. Sometimes I'll finally give him relief and masturbate him till he comes. Sometimes, I'll masturbate myself while he watches (poor soul) and make him suffer while I get off. Other times I'll strap on my dildo and fuck him while I masturbate him.

I've purchased a number of domina outfits that consist mainly of chains setting off various parts of my body. There's a chain bra and garter belt set that holds my breasts in a very provocative way. I actually get turned on by looking at myself in the mirror. Tony nearly passes out when he sees me enter the room dressed like this with my high heels clicking against the floor. Power. I'm sixty, and I can drive a man crazy with desire by how I look and act. Who would have ever thought?

I've never masturbated much. Good girls don't do this, you know. My reluctance about anal sex and B&D play was matched by my reluctance to masturbate with anyone watching. If done at all, masturbation was a completely private act, thank you. No one else invited or wanted. Tony, on the other hand, is a great believer in the wonders of masturbation and, with his creative mind, has invented a large number of ways to do it. At first he cleverly did not urge me to masturbate in front of him. Instead, he wanted to show me how he did it. I

was curious and eager to see what men did. (My ex-husband would have sooner walked barefoot on hot coals than show me how he masturbated, or even admit to doing it.) Tony showed me how he did himself in a bewildering number of ways. I was awed witnessing a man masturbating and by the number of intriguing ways it could be done. After a while he encouraged me to choose what I liked the best and to ask for repeats. He also encouraged me to create variations from these favorites. Clever man—he was actually getting me to think of creative ways to have sex, to expand my horizons.

It wasn't long before I was suggesting impossible physical feats, but at least my mind had been opened. It also wasn't long before he challenged me to "perform" in front of him. What the hell. If I could be so bold as to ask for these kinky acts, the least I could do was reciprocate.

I soon found out just how fun masturbation is. It wasn't long before I actually started looking forward to masturbating with Tony. After all, who knows better than I how much I want, how intense, how fast, how hard? What better way for my sexual partner to learn about my tastes than to watch me pleasure myself?

Tony purchased a soft, pliable dildo for me, matching the dimensions of his erect penis (6-7" long and nearly 2" in diameter) for me to masturbate with. It's shaped like a real penis and fills me up the same. It has a flared base so that I can either use it manually or sit on it and bounce up and down while pretending Tony's in me. He likes me to bounce for him when I'm masturbating in his presence. At the ripe old age of sixty I am now a confirmed masturbator and have

become so comfortable with it that I indulge myself any time I wish, even when he's next to me reading in bed.

Tony pulled off the ultimate brazen act about six months ago. He convinced me to play a game in which I would masturbate in a public setting. My first reaction was a resounding "no" and my second reaction was "are you crazy?!" He usually brings up outrageous thoughts (such as me writing this piece) while we're engaged in sex and I'm pretty far gone. My defenses are down. It's dirty pool and he admits it, but he still gleefully practices it! He convinced me to allow him to masturbate me in a restaurant by placing a vibrating egg between my pussy lips up against my clit while he worked the wired remote control and was in charge of driving me absolutely nuts until I came. Totally an insane act. Completely nuts. Yet I did it. And I liked it.

We frequently watch x-rated videos for ideas and pretend that the people in the video are actually in the room with us and that we have a mini-orgy going on. When the scene is particularly appealing, we'll stop the tape and mimic what we've seen. The idea is to get good and hot and bring ourselves to the brink, but try not to climax. We'll stop, take a breather to calm down and resume the video. This continues until one or the other of us "cracks" and comes. Great fun.

Another example of how far I've come occurred recently as we were watching a bondage video set in an English castle in the manner of "Man with a Maid." The randy castle gentleman was adept at convincing the voluptuous maids in his employ to do an extra good cleaning job in his special chambers. Naturally they were curious about the purpose of the

unusual hardware in this unusual room. He inevitably got them to agree to be placed in the restraints so that he could demonstrate their purpose and, *voilà*, they were caught. He took great delight in slowly stripping them and watching them wiggle, squirm and plead for him to stop this embarrassment. He did no such thing, of course, and soon these voluptuous women were naked or down to their garters and nylons (they were all conveniently wearing exotic lingerie) and he proceeded to delightfully play with these helpless lasses until they were "spent" (I just love that British term).

I could hear Tony moaning under his breath. I was getting pretty randy too. So I decided to stop the video and take on the persona of the castle mistress. Tony was my servant and I wanted to satisfy his curiosity about "those interesting buckles attached to the four corners of the bed" (I use these whenever I want to tie him in a prone position). I had him lie on his back and tied him spread-eagled to the four corners. After he got over his shock at this turn of events, he pleaded with me, his mistress, to release him. In a pig's eye. I told him he would be released only after he had satisfied my cravings and then only if I thought he performed acceptably. He promised to behave and do whatever I wished. I then proceeded to sit on his face and have him give me head. This was followed by my sliding down and dangling my breasts in his face so that he could suck on my nipples. After a while, I slid down further and sat on him so that he could fuck me. He, of course, was not permitted to come until I was satisfied and gave him permission to do so. I continued this pleasure triad a number of times until I couldn't stand it any more and had

a crashing orgasm while sitting on his face. After I recovered and started breathing again, I proclaimed his servant performance a great success and proceeded to masturbate him while holding his (very) erect prick straight up in the air. He came almost immediately and shot quite a load all over his chest and belly.

Can you imagine me, a nice girl, who wasn't even thinking about sex five years ago, doing all this? The "castle mistress." Unthinkable. Unbelievable. What's going on? I'm supposed to be way past any sexual desire, yet I'm getting randier and randier as I age.

We much prefer foreign-made videos. Here the actors actually look like real people; they even have some fat bulges. Their boobs and asses jiggle, their erect cocks aren't large enough to hang laundry on to dry, and their faces actually have some wrinkles. A foreign language adds to the mystique. It's great fun to watch other people sucking and fucking and to see how and what they do. I have gotten quite an education in the past few years and picked up a number of tricks and ideas. We never tire of including these in our sex play.

I have watched enough of these foreign films to have formed an amateur anthropologist's opinion about culture-specific sexual preferences. English films (at least the ones Tony picks out; I wouldn't be caught dead in one of these video stores!) favor randy themes that have fairly romantic and elegant overtones. The French lean towards bi-sexual themes, especially two men and one woman. The Dutch films are characterized by kinky things done to the women, including stuffing as many objects into their pussies and asses as

possible. Women fisting other women is also a popular theme of the Dutch videos. (I had never witnessed gay sex until I started watching these videos and I'm continually amazed and turned on by it. I just love to watch men fondling each other. Sometimes I'll have Tony bring home a gay video and spend an enjoyable evening watching men do it to each other. Circle jerks in which three or more men stand around and all masturbate to climax are my favorite.)

But the winner in the kinky and down-and-dirty xxx category is unquestionably the Germans. Those dudes know how to dream up kinky sex scenes. And the language seems to me particularly well-suited to kinky sex. Tony naturally favors the B&D films given his interest in this area, and the Germans really excel. The female domina is usually the in-charge person and is she ever in charge! She is always dressed in a very exotic and erotic outfit that nicely shows off her body. (This is where I get many of my ideas for my own erotic, domina outfits plus ideas for our own B&D play.) Both men and women are the submissive slaves and the variety of realistic-looking bodies and ages makes this very interesting for me and also believable that I could get into this type of role. The slaves, too, are dressed in exotic outfits and that adds to their sexiness. I watch these films both out of curiosity and for ideas to incorporate into our own B&D play. I don't get especially turned on. Tony, on the other hand, gets very turned on and I'm the beneficiary of some steamy sex afterwards. A win-win situation.

I'm amazed reading what I've written. I keep thinking "I'm too old to be feeling like this . . . what's going on?" What will

the future bring? I am getting hornier as I age, not less so. I am feeling more like a sex goddess and completely guilt-free regarding sex. What liberation! Will I keep getting sexier and hornier as I age? Will I be more open and eager to try new sexual acts? What an intriguing thought. It's worth hanging around for the answer. It has been written that youth is wasted on the young; I now think I know what that means.

Senior Games

❦

Tony Aiello

I'm sixty-one and my sixty-year-old partner Anne and I enjoy an active sex life. I long ago decided that sex with the same partner could be deadening because "it's the same old thing with the same old person" (at our ages, the emphasis on "old" becomes meaningful), so my method of keeping things lively and fresh is to make sex as playful and fantasy-filled as possible. We don't do this every time we have sex (no one is that inventive), but often enough so that sex play is something to look forward to and retains some element of mystery and anticipation.

Anne and I engage in an active fantasy life and do a lot of sexual role-playing. This includes erotic and exotic dress-up for both of us, but especially her. I very much like to see her dressed in sexy black outfits. These include garter belts, nylons and high heels along with partial or open bras and open-breasted bustiers. I also have a collection of bikinis and velcro strip g-strings that she asks me to wear whenever she's in the mood.

We probably have "straight and conventional" sex about 30% of the time and engage in "erotic play" the rest. Our sexual frequency is about four to six times per week. The con-

ventional play often involves her wearing a sexy outfit such as an open-breasted teddy. She gets horny pretty quickly as I play with her boobs and suck on her nipples. This leads to a fairly long fucking session in whatever room in the house suits us. Our mutually favorite position is her on top; I'm either lying on my back and she's sitting on me, or I'm sitting in a chair or couch and she's sitting, straddling and facing me. This gives me maximum freedom to hug her and to play with her breasts and nipples, which drives her crazy. She does a lot of bouncing and wiggling as she becomes more and more aroused and I, of course, am the grateful beneficiary of these delightful movements. The other two positions we use with some frequency are standing with me penetrating her from behind and with her lying on her stomach. This latter position is quite nice because my prick is softly enfolded in her pussy and my balls are mushed up against her thighs, while she's reaching under and playing with her clit. We have had some pretty thunderous orgasms in this position.

The only thing she doesn't like is anal sex; she has no interest in having my prick in her ass. However, she has absolutely no problem using a dildo/harness in my ass to fuck my brains out. We pretty much duplicate all the positions I use to fuck her—lying, sitting, standing—except our roles are reversed. She likes me best on my back so she can fuck me in the missionary position and masturbate me—or let me masturbate myself—at the same time.

We also like to masturbate in each other's presence. Sometimes one of us will masturbate while the other watches and at other times we both masturbate and watch one another. If

one is not participating, the non-participant usually controls the masturbator's actions as if directing a porno movie. The masturbator will be directed what to do and how rapidly, and is not allowed to come until the "director" permits it. The director's job is to make the "actor" as horny as possible, stop the action just before climax, and repeat this sequence as many times as he or she pleases. The idea is to be "mean" and drive the masturbator to the point of distraction. This leads to incredibly intense orgasms when they're finally permitted.

One of the games we play in either director/actor or mutual masturbation is to use vibrators to stimulate ourselves or each other. The vibrating egg with remote control works very well on her because the egg can be tucked up in the folds of her pussy and nestled up against her clit. If she keeps her legs together it will stay in place. Either she or I then control the frequency, intensity and duration of the vibrator resting against her clit by manipulating the dial on the remote control. It is really fun to watch her squirm and wiggle as one of us devilishly fools with the dial.

The electrically-operated Hitachi Magic Wand works best on me because I need very intense vibrations to become aroused enough to come. I installed a dial control in the Magic Wand's electrical line so it too can be manipulated remotely. Either she holds the vibrator against my prick, or I do, and she tortures me by using the dial to control the vibrations. It can get pretty wild and funny when we're both "wired up" in a mutual session. It eventually gets hard to worry about your partner when you're so aroused yourself.

Ever since my youth I have been a big fan of B&D sex play,

especially bondage. I've always thought it was great fun to be bound and "helpless" while my partner did whatever she wanted with my body. I've been on both ends of the dominant/submissive interaction and enjoy both roles. My nipples are very sensitive and it seems as if there's a direct connection between them and every nerve ending in my body. So playing with my nipples gets me aroused in a hurry and can keep me in this state for a long time. One of the things I enjoy when I'm on the bottom is to be tied up, with clips on my nipples, and have Anne pull and tweak them as she performs other delightful tortures on me. She has been converted to B&D role-playing, but only if she can be the domina top. As with anal sex, she doesn't like to be on the receiving end.

With some preparatory thinking and planning for these B&D sessions, she can now fairly easily get into her domina role and act out the part of mistress-in-charge. Her main enjoyment is the pleasure I get out of this play. At some point, she'll tie me up and then the fun really begins. The nipple clips are brought out and a chain is strung between them so that she has a place to tug. Sometimes she applies clips to my balls and strings chain from these through the nipple chain tightly enough so that any tug or pull on the chain arrangement simultaneously causes pleasure/pain in my nipples and balls. Sometimes she straps on her dildo and fucks me in the ass in this bound, standing position while reaching around to continue my nipple/balls torture. Depending on her mood, she may pull up a chair and have me watch her masturbate to climax, and then masturbate me before untying me. Or she might untie me and "make" me give her head and/or fuck her.

She too has a kinky bent: Her thing is to dress me in exotic women's lingerie and enjoy the sight while I walk around the house usually in a highly aroused and erect state. Black garter belt, nylons and high heels (no more than 2" please!) are a must. Other adornments include bustier, hat, jewelry, scarves. She likes to slowly dress me and then have me promenade before her while she sits nude in a chair and plays with herself. At some point she will kneel and give me head while I'm standing, but she doesn't let me come. We then reverse positions and I give her a blow job while she's standing, but she doesn't come either. If she's feeling feminine, I'll eventually fuck her in the usual way. If she's feeling masculine, however, she'll strap on her dildo and fuck me.

We sometimes take advantage of society's prejudice that people over sixty just don't do it anymore by playing a game in a public setting, usually at a restaurant. No one is aware that we two old and gray codgers are engaged in sexual play, and to the others in the room it looks as if we're having our ordinary, boring senior conversation. Meanwhile, I am masturbating her to climax.

She is nude beneath her clothes—no underwear of any kind. Shortly after we arrive at the restaurant, she goes to the ladies room and inserts a vibrating egg into her pussy and returns to our table. I'm handed the remote control under the table so that I can control the frequency, intensity and duration of the vibrations without anyone seeing or being aware of what I'm doing (at least I hope they're not!). She wiggles around and adjusts the position of the egg so that it's nestled in her pussy folds up against her clit.

It's a challenge for us to actually carry on a legitimate conversation while I play with her clit and masturbate her. She, of course, is already fairly aroused and wet just thinking about what's going to happen, so the first vibrational jolt usually causes her to gasp, sometimes embarrassingly loud. It's hard for us to keep from giggling and continue our conversation. But persist we do. She has no idea when the vibrations will occur, their intensity or their length, so the element of surprise is continually present. If I'm feeling particularly playful, I'll be mean and turn on the egg when the server is at our table. (The sound is muffled by her pussy and clothes.) I've gotten dirty looks and jabs in the leg at these times. As she gets closer to coming she has to struggle to keep anyone in the room from knowing what's going on.

This is when it really becomes fun. Eventually she gets to a point where just a slight amount of vibration on her clit will do the job and it's up to me to decide when that happens. At this point she is more than ready and is softly pleading under her breath for me to finish her off. The next vibration will do it and I love staring into her eyes when it happens. As she starts to come, her eyes first open widely and then her eyelids close tightly. When we're alone, she is free to string this out as long as she wishes. But in public this facial expression can't last for more than a moment without giving away the game.

It's a challenge for her to return to earth and begin to act normal again. We have some good chuckles after she's "back;" we look around at our younger fellow diners and wonder if they'll ever be this playful when they, too, are old and gray.

Party Girl

❧

Josephine Kay

The rules were
 • ask before touching,
 • no rude behavior,
 • no fucking,
 • no exchanging bodily fluids,
 • no drugs.

Anything else was okay. Men, women, bi's, gays, lesbians, straights, transvestites, transsexuals, B&D, S/M, tops, bottoms, butches, vegetarians, omnivores, and others were in attendance. This was a safe sex masturbation party.

With the help of many others, I started hosting these parties in the mid '80s. It was a time when many people were fearful of almost any kind of sex, and we all needed to clear the air and have fun. The gatherings went on for more than eight years, and were enjoyed by a couple of thousand people. I was fifty-eight years old when they started, sixty-six when we decided that they had run their course.

During those years my friends and I learned a lot more about our needs and how to talk about our sexuality. For my master's degree I had made a video about safe sex options for women. We played with a variety of ways to get turned on to

safe sex paraphernalia: latex, rubber, plastic wrap, any mate-
rial the AIDS virus couldn't penetrate. There's no shortage of
items available to those who are dedicated to being safe, hav-
ing fun and loving one another. I invented a thin latex "mask"
for oral sex which was enjoyed by my friends, though I never
did find a manufacturer for it.

My personal ads in the underground press read:
*5'2", 155, outgoing, upstanding, down-to-earth, reaching
out, kicking ass, off the wall, on my back, on a roll, sitting
pretty, danceaholic, round heels, unchurched, left of center,
around the bend, pansexual, ambihandrous, talkin' 'bout it,
sayin' it loud, knowin' myself, bottom heavy, air head*
(NOT) *over the hill* (NOT) . . . *you get the picture. Oh, yes,
popcorn, sushi and circus clowns.*

I've met a lot of nice folks, but I am frequently disap-
pointed to learn that very few are willing to practice the only
sex I feel comfortable with now, namely, sex that does not in-
volve any exchange of bodily fluids.

At seventy, I'm slowing down to a sprint. I need new
glasses (the better to see you with, my dear), and I have
wrinkles here and there. But I've never given up masturbating
and fantasizing. The cute new bank teller, that certain TV
news anchor, the woman at the bakery . . . and my toy collec-
tion has some kinky new additions. I get together regularly
with a group of friends who are as hungry for naked bodies as
I am. We masturbate and share massages, enjoying our bod-
ies and spirits and loving one another. And yes, I still enjoy
old-fashioned one-to-one partnered sex when it happens. In
fact, it's still an all-time favorite.

An old proverb that inspires me: If you can walk, you can dance; if you can talk, you can sing. Life is wonderful!

Knowledge is Power

❦

Fiona Blair

Sex and Sexuality . . . words not really a part of my vocabulary until I was an adult. Now, at sixty-two, I enjoy an active, varied and very pleasure-oriented sex life—but it didn't come easy.

Having been born into a very traditional Irish Roman Catholic family in the '30s, it's no wonder I knew next to nothing about sex, reproduction or birth control. In our household there was no mention of how babies happened, even though they arrived on a regular schedule. Any questions that surfaced regarding physicality were quickly dismissed, if not completely ignored. It didn't take long to get the message: Male and female genitalia were not topics for contemplation, let alone conversation.

In school I learned about occasions of sin, impure thoughts, and marital relations—phrases that were never explained, but were connected by some mysterious negative energy. Our religious teachers emphasized that it was the duty of a wife to be available to her partner, who was always a man, and to provide him with the comfort and creative opportunity that sex had to offer. No mention was ever made of abusive relationships, whether physical, sexual or psychological.

Then there was masturbation—not that I had a clue as to what that was all about. Somehow I got the sense that it was totally evil without ever having a clear idea of what the act comprised. It's amazing how much disapproval and denial can be conveyed simply through facial expressions and gestures. I was sure I must be the only one who was lacking in this knowledge and experience.

After graduating from the local diocesan high school not much wiser than when I'd graduated from the neighborhood grade school, I went on to a Catholic nursing school. Needless to say, the nuns who presided over the curriculum had totally eliminated any mention of male anatomy. In our surgical rotation, only married graduate nurses were permitted to work with physicians who performed procedures involving the male reproductive organs. This very selective program made me feel protected, but also woefully unsure of what a real intimate relationship would involve.

Enter the man of my dreams. Our marriage was doomed from the start. He, having been socialized by the same culture, was almost as ignorant about sexual matters as I. In addition, he was unable to verbalize his feelings of frustration and confusion over my reactions. I had no sense of what kinds of physical activity would bring me sexual fulfillment. My whole focus was on what my husband was interested in and, as a result, most of the time I felt very little in the way of physical sensation.

Divorce was a welcome release from a union that was hostile and abusive. Now at age fifty-one, I decided to attend graduate school at yet another Catholic institution. Explor-

ing elective courses, I chose one on Human Sexuality—one of the best decisions I ever made.

Our professor was a wonderfully open, sensitive and completely non-judgmental man. He was able to address people whatever their level of self-acceptance and tolerance. I began to read everything I could find on sexuality: I devoured books on male and female sexual behavior, public sex, sexual politics, leatherfolk, and transgenderism.

At the same time, I was exploring my own body and learning that a lifetime of sensual suppression could be patiently undone. At the age of fifty-three, I experienced orgasm for the first time—an amazing and totally awesome experience, all the more so because I had convinced myself that I was defective in some way, incapable of reaching that climax of pleasure I had only read about. The experience was not only physically pleasurable, but spiritually moving and tremendously empowering.

Since then I have embarked on a quest to understand and appreciate my own unique sexuality, which is very complex. I enjoy all sorts of stimulation. I respond to external stimulation as well as penetration—anal, vaginal, or both. I have a variety of well-used sex toys, books, restraints, vibrators, and other interesting items culled from local hardware and drug stores. I am intrigued with s/m and find it to be an instant turn-on—arousing and exotic, and so different from the way I behaved in my life as a bride of the '60s.

If I didn't have a full-time job and have to get up at the crack of dawn, I'd probably have sex at least once a day. As it is, I make do with explosive orgasms four or five times a week.

I look forward to sexual activity, either alone or with a partner, and consider it a normal and natural part of my life. I fully expect to be sexually active until such time as I become physically infirm.

Presently I am considering entering a relationship with someone I've known for a long time. Since my divorce I've had several relationships with people of both genders, and each has been a learning experience. I continue to be amazed at the myriad avenues of erotic stimulation and sensual awareness we journey through on our way to sexual gratification. Sexuality is so highly individualized that each person's response is in a class by itself.

I have learned that orgasms, while exciting, desirable and satisfying, are not the only goal of sexual activity. Whether I am with a compatible, caring and accepting partner, or I am enjoying solo sex, it is a delight to experience the sensual pleasures of my body. I never dreamed I'd be so lucky to be able to focus so fully on my own physical pleasure.

One unexpected aspect of my life is at least in part a result of my exposure to, and interest in, human sexual behavior. I am involved in teaching older folks about sexuality issues: aging and physiological changes, dating, stds, and societal messages. I think there must be lots of women like me— women in their sixties and seventies who were never encouraged to explore their sexual natures. And maybe not all of them have been able to move beyond the sometimes harsh and rigid religious or cultural barriers of family values around sexuality. I believe that the more people can share their personal growth experiences, the more able they'll be to

Fiona Blair

make personal choices that enrich and affirm their lives. Knowledge is empowering. Knowledge of one's sexual self can be life-changing.

Single By Choice

Margaret Evans

*I*n my teens I was attracted equally to both boys and girls. In my twenties and thirties about two-thirds of my sexual partners were male, but about half of my romantic relationships were with women, half with men. At twenty-one I was married for two years to my first lover; then I went though a two-year period where I had mostly women partners and I thought I might be lesbian. I married again in my late twenties and had two wonderful children. In the late '60s with the flowering of the sexual freedom movement and after my marriage ended, I had many sexual partners in relationships that lasted from a few days to twenty years. In my forties and fifties I occasionally attended sex parties, but mostly I was growing into the sexual pattern that I still practice today at age sixty-eight.

I am naturally single, naturally bisexual and naturally non-monogamous. These days I am sexual with myself about once a week, with a partner about once a month. My partners, both men and women, are mostly old friends, although I am not averse to connecting with someone new, if he or she happens into my life. I find that, as a rule, bisexual men are much less influenced by conventional sexual scripting than are straight

men. Both my male and female partners are usually bisexual.

When I was in my mid-fifties I had breast cancer, and after recovering from treatment, I decided that in the coming years I would do everything (sexual and otherwise) that I hadn't yet done. Then I realized there was not much that I wanted to do sexually that I hadn't already experienced. Now that I'm in my late sixties, I'm pleased to find that I still enjoy sex and that my libido is still strong. I don't always feel happy with my body. Like many women, I sometimes wish I had a flatter tummy and firmer breasts. But most of the time I am content with the way I look and the way I feel about my body. I do exercise and eat healthy foods, as well as enjoy "sexercise."

When I masturbate I almost always use a vibrator. I can orgasm with my fingers but it takes longer and is not as reliable. I almost always stimulate myself with a vibrator when I'm with a partner as well. My fantasy life has broadened and intensified in recent years, and I still find relating to a partner fun and easy. My idea of a close to perfect date is one where my friend and I simply hang out together in the late afternoon, then spend a long delicious evening kissing and massaging, talking and cuddling in addition to doing genital play, sometimes including intercourse. In the morning we might enjoy breakfast together and socialize for a while before parting.

My sexual encounters with partners are not as frequent as they used to be, partly because my life moves at a somewhat slower pace than it once did, and partly because I'm not quite as socially active as I used to be. I also notice that there aren't that many partners available to me, especially people in my age

group, and I wish more people over sixty, both coupled and single, would reach out and accept sex as valuable and vital.

My children have accepted the fact that I'm living a life with which I'm content and have supported me emotionally.

Although there have been times in my life when I have been focused primarily on one partner, I don't like the concept of "primary" and "secondary" when it comes to sexual partners. Most of my sexual relationships are very intimate in one way or another, and I don't like to categorize them. The best things about being single are that I don't have to live with anyone, and that I'm not half of a couple. I don't have to answer to anyone or plan any part of my life around the idiosyncrasies of anyone else (as endearing as those same idiosyncrasies may be), although negotiating and keeping agreements in an ethical way is *very* important to me and my partners.

My life has its ups and downs physically and emotionally. Continuing to enjoy various community activities and work, as well as spending time with my family and with my platonic friends, is very important to my sense of well-being. I also highly value time to enjoy my sexuality and sensuality. It helps me feel balanced and complete and gives my life the importance that pleasure can bring.

I'm glad I continue to enjoy sexual expression and see it as a creative outlet. I would like to have as much enthusiasm for music, writing and other art forms as well. I want to continue to take my life a day at a time and keep my sexual energy alive and well into my seventies and beyond.

Swingin' Seventies

இ

James Kane

Pam and I have been married forty-seven years, and still very much enjoy sex. We are both seventy-one years old.

In 1975, we started having intimate relations with another couple we contacted when we saw their advertisement in *Screw Magazine.* We'd get together to share sex about twice a year for many years. We no longer relate sexually; however, we still remain friends.

Several years ago, we started searching the Internet for other compatible couples living in our local area. Now we also occasionally entertain a single male or female, but these relationships are limited to touching, feeling and mutual masturbation.

We get together about once a month with our two favorite couples, who are both in their fifties. We have seldom chosen people under thirty. Although the youngsters are always a pleasure, they are rarely interested in an ongoing relationship with us.

When friends are coming to visit our apartment for sex, Pam and I clean our house thoroughly, scrubbing the baths and changing the bed sheets and towels. Just before our guests arrive, we both shower.

We like to get together about 10 A.M. Pam usually prepares a light luncheon to keep on hand to refresh us after the first three or so hours of sex which includes undressing each other, touching, kissing, sucking and licking in the living room. After lunch, we usually retire to our master bedroom and its king-size bed where lovemaking continues to include intercourse with each other's spouses. We prefer same-room sex, but will accommodate any couple who prefers that we enjoy one another in separate rooms.

To counteract dryness, Pam likes her partner to make love to her orally before she decides whether to use additional lubrication. I always ask that she delay the use of lubricant so it doesn't mask her natural fragrance and taste for those enjoying her orally. Although we don't consider ourselves bisexual, as often as not there is some same-gender sex: touching, sucking, licking.

We both enjoy masturbation. Pam, like many women, is multi-orgasmic. Her "personal best" is sixty-one times while masturbating during a two-hour TV show. As I've gotten older, I've found that it's often easier to masturbate than to penetrate.

When we are enjoying a day with another couple, we'll take breaks to have snacks and glasses of ice water with sliced lemon. Our get-togethers are not sex marathons. We like to take things slow and gentle. We chat, maybe give hot oil massages, and, once in a while, if everyone agrees, take photographs or videos of our sexual activities. We seldom use vibrators or other toys unless someone particularly enjoys them.

Our careful "swinging" has been a wonderful experience. We think we are healthier for it, and I personally believe that having a lot of sex is good for the prostate. Having varied experiences with multiple partners has helped prolong our own sex life. It renews the love and passion between Pam and me.

Sometimes Pam and I have a "Day of Sex" for just the two of us. Pam will put on some of her lingerie as an added attraction and we may photograph one another. Then she reads my erotic writing out loud. I think I invented our special masturbatory technique. Pam takes hold of my relaxed index finger and begins to rub her clit with it. Watching her use *my* finger to get herself off is wild! I usually tease her just as she gets ready to come by pulling my finger away. This really turns her on. After a few teases, she usually explodes!

Pam also sometimes tries on all of her lingerie for a lengthy photo session, which really arouses both of us. We like to shop for Pam's lingerie together; we buy only the finest silk and nylon. We can spend hundreds of dollars on one shopping trip.

By the way, we get all of our lingerie and nude photos developed at the local drugstore. The only pictures we have to send to a specialized mail order processor are those that depict explicit sex. We've been taking nude photographs of each since our wedding night. I keep a nude picture of Pam at thirty on my nightstand, and we have milestone nude photographs of both of us from throughout our marriage.

Those photos, and our active sex life, inspire us for the future.

Retired

ભ૭

Helen Davis

My sexuality blossomed when I retired a year ago at sixty-five and began a new relationship with Dan, a highly sexual man nine years younger than I. Sex takes time, and before retirement it was easy to put it off. I used to get up early in the morning, and immediately rush off to work. At the end of the day I would be very tired; consequently, sex was relegated to Sunday mornings. During the last few years of my marriage my former husband and I had sex less than once a week: He was an alcoholic and smoker who could only rarely get an erection. After I left him, I started masturbating more often since I finally had the privacy to do so. Still, I wasn't driven by sex as I'd been when I was younger.

Now, Dan and I have intercourse at least once a day, usually in the morning before we get busy with other things. He likes to kiss my cunt while stimulating my G-spot with his fingers as foreplay. This is a new experience for me, a fantastic turn-on. I needed a lot of reassurance from him at first before I could relax and enjoy it. Sometimes I suck his dick, but he prefers fucking.

Fucking with Dan is the best sex I've ever had. We both prefer the missionary position. Being mashed down and pas-

sive is highly erotic for me, and Dan prefers doing the moving himself, so we suit one another very well. He takes his time, entering me and stroking me slowly with his stiff prick. During intercourse, I never have had the same kind of orgasms as when I masturbate, but I feel very satisfied by our fucking. If I don't get our daily fuck, I really miss it. I have been re-eroticized by my sexy partner. He urges me to finish myself off with a vibrator about two or three times a week and I do that when I'm alone. I am working toward allowing myself to come in his presence, which is hard for me. Self-consciousness seems to block my letting go.

We wish we had met years ago, because we match each other so well in physical type, appetite, and the things we enjoy doing, and we share similar values. Sex with Dan is the best, most pleasurable part of my new life. Dan says that a day without sex is a mistake, and I agree.

Celibate

୧୨

Lyn Chevli

I have great legs, but in my early fifties I realized that I had become invisible to men—even with my legs. It wasn't that I was ugly or didn't know how to dress, or that I was frumpy or lacking in charm. And unless my judgment is way off, my personality is not abrasive. About the only difference was that I was beginning to age and it was starting to show. Even my adorable knees had developed more wrinkles than I needed. I wasn't happy about aging, but early on I had taken a firm stand against any surgical tampering. This was a moot point because I couldn't afford it anyway, but even if I'd had the money, I'm sure I wouldn't have submitted myself to the knife.

Before I became invisible I had a complicated, interesting, and for the most part, fulfilling sex life with many men. My last lover was twenty-two years my junior, handsome and creative. But even then I began to realize that the process of beginning, continuing, and ending an affair was a tedious time-consuming ritual that was not always worth it. And the possibility of contracting a sexually transmitted disease had increased.

I wanted to put more time and energy into developing my skills as a writer and no time at all dealing with men my age

or older who inevitably demonstrated an irresistible urge to mess with my life and my work, thinking they could improve it. The younger men I met were much more respectful, less controlling, and had unusual vigor. But there simply were not that many who were free enough to feel comfortable with a woman twice their age. After all, this is the United States, not Europe where age differences aren't as important. Even though my sex drive and my senses were intact, just after the age of fifty I chose to become celibate.

According to the dictionary, celibacy is defined as "the state of not being married, abstention from sexual intercourse, or abstention by vow from marriage." I carefully checked the newest and biggest dictionaries I could find to make sure there were no hidden clauses that might have been left out of my ancient *Webster's*. All reiterated the same definition, thus providing plenty of leeway in which to fool around.

With this definition, oral sex was okay as long as nothing goes inside anything else; the same thing would apply to manual stimulation, or to manual and oral at the same time—or with a vibrator—as long as you weren't married. What you could manage to accomplish all by yourself manually, orally or with a sex toy was home free in the celibacy department. That was convenient because I had no intention of becoming a nun.

Though most of us spend significant portions of our lives celibate, it is not a subject one finds widely discussed. If we are fortunate, we spend our childhood and early teen years free from sexual intercourse. The same is often true when we are elders or when illness incapacitates.

One of the shames of this culture is its inability to recognize the need for sex in the community of the disabled, and to respond to it. This unhealthy situation often leads to enforced celibacy of the handicapped. Part of the reason for our ignorance on the subject of celibacy is that it has reached near-taboo status—except in monasteries and nunneries. Celibacy is also one of the few subjects that has not yet been exploited by hack writers in the self-help genre. All of this leaves those who want to be celibate with two choices: join a religious order or make up your own rules.

Wanting to avoid religion at all costs, I chose the creative method. I decided that my commitment to celibacy would be open-ended—that is, I wasn't going to take a lifetime vow or try to prove anything. If I felt like being non-celibate, I could do so any time I wanted to. I also decided that my only partners would be my vibrator, my dildo, and any other non-human devices I desired. Fantasy, foreplay, and orgasms were definitely part of the program; shaved heads were out. I was post-menopausal and free; I felt like a child.

I was very lucky as a child: My enlightened parents owned a vibrator, which I discovered in 1941 when I was nine years old. Not knowing what it was, I plugged it in and ran it along my thighs as I sat on the edge of my bed. It felt kind of nice and tingly, but when it slipped from my hand and nestled in my crotch, it felt much better than nice. I had thirteen orgasms that day, though I was perfectly innocent about sex and couldn't name the experience.

My parents were seldom home. Like everyone else during World War II they spent many hours doing volunteer work.

That allowed me lots of time to myself. By the time I reached sixth grade, I was fully grown and had my first period. My mother told me I was now a woman and could have babies, but I still didn't know the facts of life—nor was I curious. At sixteen when I was baby-sitting, I found Van de Velde's book, *Ideal Marriage*, which explained intercourse and reproduction.

In my teens I learned how to reach orgasm without my parents' vibrator, and to construct the thigh-quivering fantasies which helped lead up to it. I find it sadly ironic that it wasn't until many years later that I learned the name, location, and purpose of my clitoris.

When I was in my early forties, my second husband and I separated and I went out and bought my first vibrator. I never used it with a partner—I found out early on that most men are jealous of vibrators. I looked upon it as mine and mine alone, and that's the way it's stayed.

When I first became celibate I neither broadcast the information nor kept it a secret. Since I was invisible, it didn't seem to matter. But then several times in mixed company I happened to refer to my status and the men immediately began to salivate, not over my lusciously sensuous body or killer legs, but as someone who was obviously broken and needed fixing—rather like a lesbian. And of course there was only one tool that could do that, and each of them happened to be wearing one. After that I pretended I was normal—just like a lesbian—and kept my big mouth shut.

Being out of the competition for sex partners was very freeing. I found myself able to look at people much more objectively than previously, and altogether I felt quite

comfortable with my chosen status. My vibrator and dildo and I remained extremely good companions and the longer I stayed celibate, the less thought I gave it.

At this writing I am sixty-eight years old and can't imagine changing my sexual status. Men play a very small part in my life. A few special ones are friends. Fortunately my sexual needs have diminished; they're still there, but are not as strong or as frequent. Since I have been blessed with a vivid imagination, I am still able to come up with interesting scenarios that are rich enough to urge me on to orgasm as my trusty vibrator hums away.

I must confess, though, that sometimes I find the whole routine tedious, and then I wait until the urge is stronger. I miss making love with men, but not terribly. Occasionally, I will have an erotic dream about a man I don't know, who holds me and caresses me in a loving and devoted manner, but his attentions are more affectionate than sexual. The truth is, I had similar dreams long before I became celibate.

My legs are all wrinkly now—mostly from the sun—but under tights they still look terrific and cause men's heads to turn. It's nothing I take any pride in. Four generations of women in my family had the same genetically-coded legs. However, I will take advantage of the head swiveling, and bat my baby blues at these men in a minor flirt. I can afford to be generous. Life has been good to me.

My Night with Zorba

❧

Silvana Simonette

*A*re you crazy?" Lissie waved her hand in the air. "That's too much for the two of us." Two bottles of champagne had been left over from my good-bye party.

"Well, then, we should invite some friends. I have to leave early in the morning, and a little champagne will help me sleep. How about it?"

Lissie immediately called Nikos. To my surprise, she announced that she wanted him to be her date. Never before during our friendship had she, unlike me, manifested a romantic interest in a man—or so I thought!

"Okay, a senior double date? At our age? I'll call Howard, from my art class. How about that?"

I couldn't imagine Lissie with Nikos, but . . . you never know. To myself I thought, *Hmmm, Nikos the Greek.* I hummed the music of "Never on Sunday" and, hands on one another's shoulders, Lissie and I took off through the living room to the lawn.

Nikos showed photographs that captured the physical prowess of his youth. The first one was of a short, thin, muscular fellow, with dark wavy hair, wearing boxing gloves and ready for attack.

"This is when I was twenty years old. Look, I'm seventy-eight now, and I still can . . . "

Nothing like the real thing—he flexed his biceps into bulging bottles, then did a dozen push-ups and stood on his head to do handstands.

Lissie, with a facial expression that said, "I don't believe what I'm seeing," quickly placed herself between Nikos and her glass table, as if to catch his feet in case of need. She rescued every antique around him by lining them up against the wall. For a moment I thought we had invited a circus. I enjoyed Nikos's crazy acrobatics and applauded with glee.

After the "show," we sat around the bottles and the champagne disappeared quickly. Soon, however, Howard left and Lissie went to bed. The grandfather clock struck midnight. I panicked.

"I have to go to sleep, get up early and drive to Orlando to take the train."

Nikos didn't budge.

After yawning noisily, I suggested we go for a walk.

Nikos sprang joyfully to his feet, put his jacket around my shoulders and took my hand.

The evening was balmy, with a soft breeze that refreshed our skin and caressed our hair. The bay sparkled with shimmering reflections of the full moon.

We walked along the water's edge above a five-foot drop. Tipsy from the champagne, I tripped near the brink and in a terrifying moment saw myself falling into the black abyss, my head crashing against the rocks. I screamed and reached out to grab the nearby bushes, but my fist closed into nothingness.

I felt a strong hand on my arm pulling me back, jerking me onto the grass. Nikos tumbled down near me.

"My God, you missed it by a miracle. I don't want to think about it"

"Me neither—I'm all shaky"

In a mixed flash of surprise and fear, our bodies intertwined. I felt his warm, champagne-smelling breath close to my mouth, his tongue on my lips, eager, hungry, searching for my kisses, his hand fondling the curves of my body. He swung my arm around his neck and I pulled him toward me, caressing his white hair, wavy, soft, lavender-fresh. His deeply-honed face appeared grotesque in the moonlight, but handsome, like that of a rough sculpture in the making.

"Your arms are so warm, Silvana dear," he crooned, "like the waves of the sea when they rock you."

"What lovely poetic prose . . . "

He tenderly murmured Greek rhymes into my ear, with a loving, deep voice. His lips reached down my neck and his hand slipped under my blouse.

"No, Nikos, someone may see us," I murmured, licking his ear.

He ignored my protests, moving his hand over my breasts. "Give them to me, they are full, so full."

"No, no, let's not stay here," I wiggled under him. "The guards make their rounds with big searchlights. The police come every half hour."

"Nobody can see us. Look, feel it." He put my hand on his crotch. "I'm full for you."

"I want you too, but if they report us, Lissie will hear about

it. I won't be able to show up at the club ever again."

Nikos was nothing if not persistent. "Let's move behind that hedge. Come, Silvie, come."

Confused, excited and dazed, I stood and allowed Nikos to lead me behind the thick hedge. We would be well hidden, but I had never done anything like this before.

My head was spinning. My body shook in spasms. My labia opening like a flower, the nectar flowing, I wanted to let go, to see the stars whirling in a vertigo of mad enjoyment, to reach the sublime instant of complete oblivion in the arms of a man, a man like Zorba.

I was torn between passion and fear, and realized that the dread of being discovered was actually adding to my desire. Our bodies twisted like two dancers on a stage floor. Somehow we took most of our clothes off and the dance continued. First one of us on top, then the other, together in a duet, a dance of love, romantic and sensual, passionate and free— my legs stretched up against his shoulders, his penis inside me, his mouth on mine. Fueled by the champagne and the novelty of a secret love, I reached orgasm with that ecstasy that transports you to Nirvana for a sublime moment and sends you to the zenith.

"Together, Silvie dear, that's right, my baby, together. Aaaaaaahhh."

We lay on the grass behind the hedges, wet with sweat and dew.

"You're terrific, babe," he murmured, holding me close.

"And you're sensational, Nikos—your kisses, your poems, your passion."

The next day, exhausted but happy, I boarded the train for home. Once I'd settled into my compartment, my thoughts turned to Nikos. The theme song from "Never on Sunday" ran through my mind, and soon, as a young girl again, I was dancing with Zorba the Greek on the beach of an Aegean island.

Submission

ᥴℐ

Jim Hall

This year marks my sixty-second birthday. My wife Sarah and I just celebrated our fortieth wedding anniversary. Through good times and bad, I have never seriously considered leaving her; I love her deeply. But in spite of our love and commitment, we never got it together sexually.

All my life I've been drawn to being submissive to women, having them dominate me, punish me, humiliate me. Sarah will have no part in that. We are not sexually compatible.

Our sex life kept dwindling until it became non-existent. Sarah literally lost all interest in sex, and I wondered what to do. I was not ready to put my sexuality on the shelf and forget it, but I didn't want to leave her. Nor was I ready to go out and find another woman to meet my sexual needs. Depression set in as I struggled with my sexuality. It finally reached the point where I had to get some professional help.

I secured the services of a competent mental health counselor and explained my dilemma to him. I told him that my wife thought I was a sicko for my sexual masochism, how she claimed that "no real man acts like that." I had no self-esteem. I considered myself a sexual pervert, and I felt worthless.

The counselor asked me what I wanted to do about my

sexuality, and pointed out several options. I could divorce Sarah and find someone with whom to act out my fantasies. This was not an option to me—regardless of how poorly Sarah and I communicated sexually, we were in love with each other and did not want to abandon our marriage.

The second option was that my wife and I could come to an agreement for me to find another woman to be sexual with while staying in my marriage. I knew this wouldn't fly—my wife wouldn't even consider it.

The only option left was for us to keep our marriage intact while finding ways to meet our needs. For Sarah that meant no sex. For me it meant being able to indulge my masochistic fantasies.

My counselor told me that if I could reach the point of feeling comfortable with my sexuality it would be much easier for me to figure out what to do. He said that my particular sexual proclivity was neither good nor bad; it just was. Like a bottle of beer, it could refresh one person, or destroy another. By itself the beer is neither good nor bad; it just is.

That had a great impact on my life. I sat down with Sarah and explained that I saw myself in a different light. I no longer viewed myself as a sicko but as a healthy sexual person, and I intended to enjoy that aspect of myself. We admitted that although it would be impossible to merge our sexual beings, we still didn't want to terminate our marriage.

About this time my wife, who knew I suffered from foot problems, bought me a massager, thinking it might help. It did work well on my feet; then a light bulb went off in my head and I began experimenting with it on my penis. It didn't

give me an instant rush, but aroused me very slowly. This was a new experience for me; for the first time in my life I relaxed and enjoyed the sensuous feelings rather than rigorously pursuing a climax. At the same time, I allowed my sexual fantasies to roll through my head.

Now that I'd accepted my sexuality, I sought out books and magazines that featured dominant women. Then I discovered the Internet with its many websites offering a vast variety of ways in which dominant/submissive sexuality is played out. Most of these websites are operated by dominant women. They display photos of men being dominated by women through bondage, cross-dressing, and spanking. Fictional stories are also posted on the sites. These websites offer me a way of dealing with my sexuality. Now I've written stories for some of them, allowing my imagination to run wild.

This is the best I have ever felt about my sexuality. I am at peace about it. I no longer fear that people will find out I like being submissive to women. I feel cared for and needed when submissive. I am at peace with the world when I have surrendered to women. I like myself; I like who I am.

My marriage has never been better. Sarah is still not interested in sex, but we enjoy cuddling, caressing and hugging. I am happy and satisfied using my vibrator, the Internet, books, and writing to recharge my sexual batteries and spice up my fantasies. I am happier now than at any time in my life.

Still Growing

☙

Willie Baer

I am a seventy-two-year-old man, very active and young at heart, in a loving and committed relationship with my wife of many years. I was slow to become sexually active—regretfully, it was only after my first twenty-year marriage had ended that I learned how to appreciate the depth and range of intimate pleasures and love that are possible in a long-term relationship. It is never too late in life to discover how to create positive attitudes about sex and intimacy and to experience deep love and closeness with a partner.

I can thank my parents for never having instilled in me any negative attitudes toward sex, but at the same time, neither did they teach me anything positive about sex. They simply never talked about it. I didn't have intercourse until I was married at twenty-three.

After my first marriage broke up, my real sexual awakening began. The Bay Area in the '60s was full of organizations and programs that promoted human growth and potential. I attended many programs and workshops on intimacy and sexuality. Among other things, I learned how to become aware of and accept the variety of sensual feelings in my body, to talk about sex with a partner, to listen to and be sensitive to what

my partner wants, and to verbalize what feels good to me.

These experiences enabled me to let go of my preconceived notions about what is right, proper, or wrong about sex; my emotional, spiritual and physical experiences opened to new depths, and enabled me to improve my communication skills.

Eroticism involves more than physical sensation. It means being fully aware of the connections between those sensations and one's feelings toward another person. With each succeeding year of my life I have become more aware of how love and compassion deepen, and how the expression of our sexuality together adds to the depth of our relationship. When we give our love to each other it sometimes feels like we merge into oneness.

I have become more aware of the dimensions of maleness and femaleness—the yin and the yang—that are present in both sexes, and of how feelings and sensations can shift from one location in the body to another, both in myself and my partner during lovemaking. Frequently during lovemaking I am aware that my entire body is a sensual organ.

As I advance into my seventy-plus years, my view of what is "conventional intercourse" has changed. Although I frequently experience complete orgasms I do not have an urgent need to ejaculate. I have discovered that by slowing down and letting go of the need to ejaculate I can prolong a climax for long periods of time and often experience multiple orgasms, sometimes without ejaculating. Now I enjoy intercourse as much as, if not more than, before.

My sexual feelings now are not just centered on my penis but have grown to include many other parts of my body in-

cluding my mouth, neck, ears, nipples, and the entire perineal and anal/rectal area.

I derive great pleasure in oral sex, both giving and receiving. Anal stimulation is also a highly erotic form of sex play for me. If anal sex is to be enjoyed I believe it is important that the rectum be thoroughly cleaned and for partners to be very sensitive to each other's reactions. I have even found pleasure in the process of cleaning myself rectally in the anticipation and preparation for anal sex.

Contrary to a view that sexuality inevitably decreases with age and that sexual feelings diminish over time, I have found the process of growing older and maturing can become a time for increasing sensual feelings and expanding intimacy and love.

Satisfied

❦

Sal and Al Pine

*M*y partner, Al, and I are both well into our seventies and we enjoy a healthy sexual married life. Two of the most important elements of our sex life are watching porn videos (often with the sound off), and my masturbating with a Hitachi wand, the Cadillac of vibrators. Pornography, fellatio, cunnilingus and finger-fucking rev us up. At seventy-two my husband still gets erections and penetrates.

We bought a vibrator years ago at the Museum of Erotic Art. We also presented two dear friends (one who's now over ninety) with similar vibrators, and they treasure them.

Sometimes Al's cock isn't very hard, or he can't get off as he did in earlier years, so he turns on a porn video and gradually works himself up to an ejaculation. Then I turn to my Hitachi. The strong vibing carries me off into high ecstasy. Thus, we are both happy and fulfilled. The pressure to perform is off my beloved partner and we each complete our pleasuring in our own way.

We had some help getting to this level of joyful freedom. Betty Dodson was more than a guru for us. Her 1972 manuscript "Liberating Masturbation: Betty Dodson Speaks about Erotic Art, Masturbation, and Women's Liberation," was the

first gift Al ever gave me. From that treasured mimeographed treatise I learned to love my body "down there." I was forty-six, and this became my Declaration of Independence. Even today, at seventy-two, Betty's Epilogue still inspires me:

*I have a sexual fantasy about my old age. There are about seven of us feminists living together in a collective. Our ages range from seventy to ninety. Every night we gather in front of our closed-circuit TV and watch our pornographic video tapes. We light the incense, get stoned, put on our earphones and plug in our vibrators for several hours of ecstasy. The rocking chairs creak, the vibrators hum, and we occasionally tap each other, smiling and nodding, "Yes" after a particularly good orgasm.**

Al and I have learned a lot from pornography. I've learned about fellatio from watching those young women please their partners, while sensual touch and finger-fucking are now natural to my husband. What fine educational tools some of the porn videos would be for many frustrated young people.

We used to be into the swinging scene, but not since we moved north when I was sixty and Al was sixty-one. A dear friend who was a leader in the intimate, sensual workshops we had participated in died of AIDS a few years ago. Maybe our age is also a factor in our no longer wanting to be a part of the swinging scene. We doubt if there would be willing folk to swing with in the little rural town where we now live.

Though Al misses the sexual intensity of youth terribly, he recognizes that our loving is still goooood, as he says when we are in the throes of passion, and he is slowly adapting to being seventy-plus.

* *"Liberating Masturbation,"* Copyright © 1972 by Betty Dodson. *Betty's classic manuscript was self-published as a book in 1974, expanded into her wonderful book* Sex For One *in 1987, and revised in 1996 (Three Rivers Press/ Crown Publishing, New York).*

Never Too Late

ↁ

Richard Flowers

*M*y girlfriend is a few years younger than I, in her mid-sixties. Since our first encounter five years ago, we have met once or twice a week, and we spend holidays together. Our dates begin with a few kisses, and rapidly develop into the slow removal of clothes. We alternate between inter-course in missionary, doggie, side-by-side, and her-on-top, as well as cunnilingus. One aspect of sex technique which I think has gotten too little attention in the literature is manual stimulation. We use the two-handed treatment. She lies on her side facing away from me, top leg drawn up, while I put one hand underneath and around her legs, and the other hand approaches from the back between her thighs via the buttocks. In that way I can play with her clitoris with one hand while dipping a finger of the other into her vagina. I can feel the base of her buttocks and perineal area, which drives me wild. We both find this very exciting, and it is usually fol-lowed by energetic and enthusiastic fucking.

We have found that bed height is important. On her new bed, she is at exactly the right height for me to stand on the floor, enter her at the right angle for G-spot stimulation, and simultaneously rub her clitoris with my fingers. With this

method, she has experienced orgasm during intercourse for the first time in her life. It is also wonderful for me. For the first time, at the age of nearly seventy, I have had the satisfaction of bringing a woman to orgasm with my penis. After half a lifetime of frustration and disappointment, I am getting all my sexual needs and fantasies met. I find it hard to express how lucky I feel and how grateful I am.

I am conscious that my libido is not what it was when I was younger. My capacity to orgasm is limited to about once a day. I like to fuck more often, but I don't come every time. This is fine with both of us. We have His and Hers orgasms, and occasionally Our orgasms.

People say "use it or lose it." Some also say, which I now know to be a lie, that sex fades away with age. In this case, in spite of all the unpropitious circumstances, two people in their sixties came together to create a wonderful sexual romance. I am so glad to be one of them!

Spice

❦

Helen Michaels

*H*aving sex after sixty has made me realize that age has very little to do with sex. I may view it a little bit differently, but my desires and needs are still there.

Since our retirement, my partner Michael and I have had time to get to know each other again in a new way. We are relaxed with each other and able to have sex exactly how we want it, with no inhibitions or distractions. We now enjoy sex the way it was meant to be, exploring and discovering the things we enjoy.

It has been important for us to smell, feel, and taste anything and everything, and to experiment until we find something that we both enjoy. We like to read about other people's sex lives and fantasies; this gives us new ideas, and encourages us to explore new territories. We've also found videos helpful; we like to watch what other people do, and see how they respond to each other. It's fun to see something that we've never done and then try it. What do we have to lose?

Getting rid of old-fashioned inhibitions was one of the first things on our agenda. Being inhibited was one of the biggest obstacles to my having great sex, as well as not being satisfied with my body. The solution has been to re-educate

my mind and recognize that sex involves both the mind and the body. My mind tells me I want the kisses, the caresses, the gentle invasion of my body and the fulfillment of a deep, gratifying climax. I have to fight the inner voices saying "You're too fat; you're not slim enough to enjoy sex the way it should be enjoyed." Nonsense! My body is sexy and sensuous.

Michael and I sometimes enjoy pretending we are having an affair, or that we're strangers having sex for the first time. It adds a wonderful edge to our sex life. We love to take each other's clothes off one piece at a time, while kissing and licking every part of each other's bodies. Then, when all the clothes are off, one of us will masturbate while the other one watches. What a delightful turn-on! It starts the evening off with a bang. We like to masturbate together until just before coming, and then, when we can no longer stand not touching one another, we come together.

We both love oral sex—I can't imagine how someone wouldn't. For me it is one of the most personal and intimate aspects of sex. I start by touching him, letting my tongue glide over every part of his body until I reach his genitals. I always pause and take in the aroma and then kiss and lick his cock before putting it in my mouth. It is so intimate to have my mouth and tongue on my lover's penis, sucking and licking it and inhaling his scent.

I often put my finger into Michael's anus to make him come. It is very exciting to feel the spasms deep inside his rectum. It is so exhilarating to be able to make him come this way. I also love it when he puts his finger in my vagina while his tongue and mouth suck my clit and my lips. When he

makes me come this way, it leaves me breathless.

It spices things up to have a sexually uninhibited partner who will allow me to do just about anything I want. Sometimes I dress Michael in bras and silk panties (he loves the feel of silk on his balls and cock), silk stockings, and whatever else hits my fancy. Having sex with him when he is dressed like a woman is very exciting to me, and he loves it as well. It's like making love to another woman, and even though I don't want to do that, pretending Michael is a woman is a turn-on.

We also like bondage. I'm not talking about S/M, I'm talking about tying Michael up and doing whatever I want to do to him. It's doubly exciting if I blindfold him. Michael has had objects inserted in his rectum, earrings attached to his nipples and balls, his cock tied up with earrings hanging from it, and his balls pulled and stretched. He's also done similar things to me.

It turned out that both of us were interested in golden showers, but were very embarrassed about it at first. However, once we'd done it, it turned out to be very exciting. Having Michael's hot pee all over my body and in my mouth is sexually stimulating to me. And I love watching his excitement as my pee drizzles onto his balls. Sometimes I pee in my underwear, and then stuff my panties in his mouth and make him suck on them while I continue to pee all over him. It's thrilling to do something that is considered outside the "sexual norm."

I feel a good deal younger than my sixty-plus years. Part of that is undoubtedly because of my new-found sexual freedom. Keeping sexually active has exercised my body as well as

my mind, causing me to feel and believe that I am indeed younger, and enriching all other aspects of my life.

Thwarted ResErection

❧

Doug Harrison

I perched unsteadily on the edge of the wobbly chair in my doctor's office, my brown trousers around my ankles and my black jock stretched tightly between my hairy, trembling legs. My long, soft dick pointed toward the cotton pouch, eager to return to its warm home and escape the sharp hypodermic gun aimed at its shaft.

"Just pull the trigger! You'll hardly feel it!" the doctor urged. His clinical attitude toward this procedure was disconcerting, like the antiseptic setting of his drab, salmon-colored office.

My fear masked the embarrassment I felt after reluctantly admitting to a recent difficulty maintaining erections. I was a tall, sexually active San Francisco man and the domestic partner of another bisexual man. We had an open relationship. My libido remained strong as I aged, but I was increasingly plagued by flagging erections.

Realistically, I didn't expect to respond to my lover and other partners like a teenager who gets super-hard immediately upon being stimulated by such extreme turn-ons as walking up stairs or riding on a bumpy road. I just wanted to improve my staying power, not only for my benefit, but for my partners' enjoyment. The doctor had presented various

options, such as penile implants and vacuum pumping. Self-injection of a vasoactive medication directly into my penis was our agreed-upon choice. I felt it was a safe, middle ground between surgery and a bulky pump.

To relieve the trauma of penile self-injection, my doctor had recommended an automatic injector. This formidable-looking contraption consisted of a spring-loaded syringe housing with depth adjuster, observation window, primer, safety interlock, and firing button. A lengthy explanation had been necessary for various procedures, such as cleaning the medication vial and penis, loading the syringe, placing the syringe in its housing, and priming the device. He insisted that I practice these procedures under his tutelage.

I took a deep breath, gritted my teeth, looked away from the gun, and pulled the trigger.

The syringe was empty in a few seconds, and I felt only a slight burning sensation. My mind was a disoriented blank, a veritable *tabula rasa*. My cock retained its passive indifference for a few moments.

And then it started. As if it had a mind of its own, my cock began to harden until it was pointing straight ahead. My face turned cherry red. The doctor smiled knowingly.

"It should stay hard for about two hours. If it doesn't, then we know the dosage needs to be increased. If the erection doesn't subside in four hours, I have an antidote, but I've never had to use it. If an erection lasts more than six hours, you can become permanently impotent, so go to an emergency room if you have such difficulties. But that won't happen."

It was 4:30 P.M.

I pulled up my jock and pants. It was difficult, but not im-possible to squeeze my member into the jock. As I waited at the receptionist's window to settle my bill, the doctor stopped by to see how I was doing.

"I'm only semi-hard," I remarked.

"Perhaps we'll have to increase the dosage," he said. "Let me know."

Since the doctor's office was close to my mother's home, I decided to pay her a visit. I felt that my loose trousers and tan tweed sports jacket would provide a suitable disguise for any protuberance, particularly since she had vision problems.

"How unusually nicely you're dressed," was the first barb she threw. "What's the occasion?"

"I had to meet with customers this afternoon." I sat down in my deceased father's favorite rocker. We exchanged pleas-antries. Somewhere between the recitation of how my job was progressing and the results of my son's latest soccer game, I felt a noticeable discomfort in my crotch.

Sitting in this rocker would at times give me the eerie feel-ing of being at one with my father, of almost being him; involuntarily I would assume his posture and gestures. And here I was, growing a real boner! With Oedipal cringes racing through my mind, I made a hasty retreat, promising to visit Mom again soon.

My next stop was Long's pharmacy. While strolling along the aisles, I realized that the pressure in my cock was becom-ing extreme. I picked up my pace.

"Perhaps I don't need extra toothpaste after all," I decided.

No matter how I hopped around trying to rearrange my dick, horizontal or pointing straight up in the jock, it remained painful. And trying to make it point straight down was impossible.

I peeked around the corner, and was alarmed to notice a woman walking toward me. I quickly changed course, and again futilely attempted to find a comfortable position for my cock. There was now a very noticeable bulge in my trousers. I covered it with my jacket, hurriedly left the store, and drove home.

It was now 6:30.

It had been two hours since the fateful injection. "Shouldn't it start to soften?" I wondered, somewhat worried, but not alarmed.

I undressed and admired my throbbing cock in a full-length mirror. It pointed upwards (amazing for a man of my age). I hung a large heavy black bath towel from it. My dick didn't budge. It looked huge. Folks have remarked about the large head on my member, but this seemed swollen out of all proportion. Purple veins along the shaft stood out against alabaster flesh. Everything hurt like hell. Nonetheless, I stroked it gently, but decided to postpone gratification until after dinner.

Since none of my housemates was home, I decided to cook dinner bare-ass with the somewhat naive hope that I would be more comfortable. After scrounging for leftovers, I put the remains of a casserole in the oven.

The timer went off. When I removed the casserole from the oven I missed burning the end of my dick by a micro-inch.

The front door opened and in walked a housemate. I ran to the sink, got as close as possible in my condition, quickly turned from him and fumbled with the dishes.

"Caught you with your pants, down, huh, Doug," he laughed. I smiled agreeably. He left and I put on loose shorts.

It was now 8:30. Antidote time.

I retired to the atrium to eat. As I nursed my dinner and painful erection, the winds howled and the rains beat mercilessly against the glass roof and walls.

It was now 9:00.

Waves of fire were undulating in my midsection. They were not surges of passion, but swells of panic. What would it take to finally get rid of this painful boner? Would I be impotent? Had my greed for unconditional sex taken me from flagging hard-ons to no more hard-ons, period? I decided to go to the hospital.

I changed into black sweatpants and a red sweatshirt, threw on a warm jacket, and hurried to my car. I squeezed my hard-on under the steering wheel. The trip took about thirty minutes, ten minutes longer than usual due to poor visibility.

I arrived at the emergency complex and was told by the attendant that I could not park in the lot adjacent to the emergency room. I resisted the temptation to describe my condition and plead for absolution, and instead parked far away. After a long, painful walk, I dejectedly entered the building and went toward the entrance to the emergency waiting room.

Something obstructed my path. It was a walk-through, magnetic airport security monitor. "Oh God!" I thought. An

old Mae West joke forced itself into my blood-deprived brain: "Is that a gun in your pocket or are you glad to see me?"

I passed through the detector, smiled at the crusty guard, and stood in line waiting to tell my sad story. I was exhausted. Panic gripped my stomach like heavily muscled hands wringing sludge from an old towel.

At last it was my turn. I sat beside a dingy, cluttered desk at which a friendly-looking matron was seated. Her computer station peeking out through mounds of paperwork seemed out of place. "What's your problem?" she asked.

"I have an erection that won't go away," I stammered.

She took a slow, deliberate look at my crotch, wrote a few words on a piece of paper, and said, "Priapism. Take a seat and we'll call you."

I looked around the room. It was about half full, mainly with couples, and most of them with children. I picked a seat as far removed from the clamor as possible and began my wait.

It was now 10:00.

Several small, restless children were running around playing tag. Several times they bumped into my chair and almost tripped over my legs. Their mother finally corralled them back into their corner. I was relieved: I wouldn't have wanted one of them to land on my lap.

My name was finally called, but, alas, it was only to determine if I was financially solvent enough to warrant the hospital's attention. Part way through the interrogation the young female clerk asked what was wrong with me.

"I have priapism," I blurted out.

"What's that?" she asked.

"I have an erection that won't go away."

Long pause. Slow smile. "I can think of worse problems."

Well, at this point I couldn't. I wanted to scream because my dick hurt so damn much. And I needed to piss. I went to the bathroom and locked the door. Then I double-checked that the door was really locked.

There was no urinal. Peeing in the sink was not possible; I couldn't possibly bend my dick that far. Likewise, I didn't see how I could piss in the toilet. Perhaps only a man can relate to the awkward and impossible situation of trying to pee standing up with a hard-on that won't bend at all (even a morning erection is somewhat pliable). I finally found a workable position by crouching over the seat, pointing my head toward the grubby floor, and aiming my boner toward the upper, inner front of the bowl. I was now turning crimson, and developing upper leg cramps. Remarkably, the sought-after stream soon materialized.

I staggered back to my seat, and noticed that a young, attractive woman cradling a three-year-old boy had seated herself opposite my chair. We exchanged smiles. She told me that her son had a brain tumor, his life expectancy was uncertain, and he was prone to seizures. There had been many trips to the emergency room, most requiring long waits of several hours. She didn't know my problem, and hoped I didn't have to wait as long as she usually did.

My problem was certainly trivial compared to her son's. When they called my name before hers, I really felt bad, but the throbbing in my crotch prompted me to move rapidly to-

wards the patient area.

It was now 11:00.

A nurse escorted me into one of many cubicles separated by white curtains. These provided visual, but not aural, privacy. I spoke in a whisper. Knowing my situation, she allowed me the luxury of wearing the hospital gown backwards, permitting frontal opening. I, of course, cinched it as tightly closed as possible.

A doctor came in, examined me, asked what medication I'd been given, and left to call the urologist. Another wait began.

Next a diminutive female doctor appeared. She was not the urologist, but nevertheless insisted on seeing "the problem area." I was annoyed, and didn't think she had any business bothering me. So I flashed her, thinking, "Eat your heart out, baby."

The parade continued with the appearance of not one, but two urologists, one of whom was an intern. I wondered if the cute, younger one was gay. Again an explanation and examination of my extreme vascular congestion, followed by nods of disapproval, and a whispered huddle.

"Do you get full erections?" I was asked.

"Yes, but they don't last as long as I would like," I replied.

"If you get full erections, you should never have been given this treatment! You should use a cockring instead."

So much for unanimity in medical treatment, I thought. I was also flabbergasted that a doctor would use such a non-medical term as cockring—I had been under the impression that it was the copyrighted designation for the basic item in every gay man's toy bag.

The younger one looked at my hard-on and asked, "Have you used this?"

"No," I replied. "Just give me the antidote, and I'll be on my way."

Two wicked smiles. "Oh, we don't give antidotes. We'll have to drain it instead."

A very large syringe appeared. My eyes widened.

"Don't worry. We'll numb the area before inserting this."

A very small syringe appeared. A local anesthetic was injected about two inches from the base of my penis. Then Monster Needle was inserted in the same spot.

Blood was very slowly drawn from my penis.

"Look at that!" one of them gasped. My penis had softened for a length of about two inches starting from the base and continuing up the shaft. But the remainder of the shaft and the head were still very hard. I was not amused.

"I wonder if this is reversible?" the one wielding the syringe questioned. "Let's find out!"

So, in the spirit of rational inquiry, he slowly injected my drug-infested blood back into my penis. Sure enough, it got completely hard again. Two, but not three, smiles.

"Let's empty it all the way out," the doctor said at last. When the syringe was full, and my cock empty, normal detumescence finally occurred.

We all relaxed. I was cleaned up and told to report to the office in a few days for a check-up and a demonstration on the use of cockrings.

I still had to suffer the indignity of an antibiotic injection administered in my ass by the sixth person to enter my cu-

bicle. At least the clergy wasn't called in! This last visitor was a kindred gay spirit and very empathic. I finally felt comforted after my agonizing experience. Then I left for home.

It was 3:30 A.M.

I quietly entered the house, stripped, and crawled into bed. I was completely exhausted. I lay on my side, and immediately fell asleep, with my soft penis in my right hand and a smile on my face.

Epilogue: A subsequent penile injection was tried with a different drug and smaller dosage. My erection was reasonable and lasted approximately two and a half hours without any discomfort. It was then discovered that my body was not producing enough of the hormone DHEA. When this was corrected, my staying power returned to normal, without intervention.

Before the DHEA remedy, I approached sexual situations with trepidation, wary of a potentially unsatisfactory response. Afterwards, I was much more comfortable, able to concentrate on my partner without worrying about a flagging erection. I felt liberated, and my self-confidence returned. The time I spent with secondary partners was more relaxed, without performance anxiety.

My trip to the emergency room taught me to be patient and to study chemical balance rather than go for a quick fix. Hopefully this lesson will carry into other situations, as I'm presented with more challenges by the inevitable aging process.

Stroke

❦

Thomas Matola

I am sixty-seven years old, and recovering from a stroke I had six years ago. People often ask me if there's life after a stroke. With enthusiasm, I say yes; disability can and often does lead to great sex! If there was sex and love before the stroke, there will be sex and love afterwards.

I must choose what I eat carefully, chew deliberately, and swallow with full attention, or else I might choke. I delight in a single raisin and have learned that gulping giant mouthfuls makes me miss the nuance of the flavor. So it is in sex. Each caress, each kiss, has my full attention. As a disabled person I must live in the moment, and sex is no different. Slowly attending to the senses, feeling, smelling, tasting, hearing, seeing, I find ecstasy in sexual coupling.

Not surprisingly, it took my partner and me a lot of time to learn ways of compensating in lovemaking. We earned an unforeseen dividend when we found we had to communicate for this purpose. We learned to speak more honestly and openly, making our entire relationship better.

After I had the stroke I began asking doctors and nurses about how it would affect my sexuality. Many of them were embarrassed, some laughed, and all shrugged their shoulders

and said they didn't know. I got the message that nobody wanted to talk about it, except me. I did have erections. I told everybody about it. Again, the responses were mostly perfunctory and/or embarrassed. I asked about achieving orgasm, and again they shrugged. While everybody was willing to talk to me about what I might expect with rehabilitation and movement on my right side, and about speech improvement, nobody wanted to talk about sex or my sexual organs.

This forced me to discover on my own the challenges and joys of sex with a disability.

I began various kinds of therapy, including horseback-riding. Although I hadn't expected it, I found both my emotional and psychological health greatly improved. A sense of well-being seemed to accompany the exercise.

What came as an even bigger surprise was the improvement in my sex life. The "how-to-do-it" sex manuals usually stress the importance of strengthening the pelvic area in order to achieve greater sexual satisfaction for yourself and your partner. Riding a horse is an excellent exercise to this end. In order to stay on a horse, one must sit properly and move the pelvis in rhythm with the horse's three-dimensional motion. The better the rhythm is maintained, the better the ride. The more one rides, the more one's endurance improves. The same can be said for the sex act. Sex has greatly improved for me as a result of therapy and psychological and physical work.

Imagination fuels desire and libido. While my partner and I find that our genital areas are important, of equal value in

sexual activity is stimulation of our whole bodies. There are many nerve endings in the skin, and we love to explore the sensations, concentrating on what feels good. We explore all our senses—smell, taste, sight and sound.

As Dr. Ruth says, "Sex is not just about procreation, but it is also recreation." For those of us over sixty, enough said about procreation. Let's focus on the recreation. The fun part. Sexual feelings and thoughts about sex are always with us, even when we are sick. My experience has shown me the importance of educating medical caregivers, who are otherwise very caring, to understand our sexual nature, and to have a positive and open attitude about sexuality.

Toys for Grownups

ℰↃ

Caroline Smilley

This year I celebrated my sixty-second birthday. I'm a pretty active lady; I love to take walks, love to dance and go to movies. I am a grandma for the first time, which is a lot of fun. My husband and I watch our grandson two days a week, which is just enough. I have a very open mind; my dad raised my sister and me to go through life without blinders. Always look to the right and to the left, he said. I try to widen my horizons.

Now, about our sex life: My husband and I have been married for almost forty-two years. Whew! I have never had another sex partner. We were married young, in our early twenties, and when you're young the juices just flow naturally.

My husband is not creative in bed. He doesn't try new things, so as we get older I've had to experiment on my own.

I used to work part-time with a lot of younger women and we would talk about sex now and then. One day a young woman asked me if I'd ever used a vibrator. I said, "No, of course not," and she said I didn't know what I was missing. Eventually I decided, why not try, and I asked her to get me one—I was too embarrassed to go and buy one myself. She got me one of the straight skinny plastic ones that looks like a

tube of lipstick, only about six inches long. That worked okay for a while, but I knew I had to move on. So eventually I ordered a vibrator with a beaver on the end from the Good Vibrations catalog. When I used it, I had an orgasm like I'd never had in all my life. I'm not much of a fantasizer, so sometimes when I'm using the vibrator I'll watch a movie on one of the adult channels and before you know it, wham! I also like to read erotica. Now I also have a Pink Pearl vibrator which is just for the clitoris. The vibration on the outside of my vulva makes me feel so alive.

At first my husband didn't like my toys too much, but little by little he's gotten used to them. I love it when he uses the vibrator on me. He can get to certain places more easily than I can sometimes. At first we felt very awkward, but now we just let ourselves relax and have fun. It's wonderful. We also use estrogen cream on my private parts so it's a little smoother. It feels very good.

I'm very tempted to try a few other things but my husband would never go for a lot of the kinky stuff I see in catalogs. He kiddingly calls me a pervert . . . well, maybe he's not kidding, but I don't care! I have taken care of him sexually for a long time—now it's pay-back time.

All my friends grew up in the '50s and are good Catholic girls. If they knew what I was doing they would probably think I'm a sex maniac. I think they're losing out. It's wonderful to grow old with someone I love and be able to enjoy my sex toys too. Everyone gets old, and if we're able to have fun while doing it, why not?

Sex After Sixty

℘

John Oldman

As I approached sixty, my difficult marriage was in its last stages, and I was confident that with a compatible partner I could enjoy sex again as often and as much as I had ten years before. My only concern was that by then my sexual interests and energies would have already started their decline. Little did I know what lay ahead.

With the marriage over, I had a chance encounter with Vicki, a good friend from some years before. I was then sixty-one. Fortunately for me, Vicki loved me deeply and kept me going as I fought the ravages of rage and depression during the terribly painful divorce proceedings. For more than a year my libidinal energies ranged unpredictably from no interest whatsoever to insatiable neediness. Even so, our sex life quickly fell into a once or twice a week pattern. Although I had always thoroughly enjoyed oral sex, it turned Vicki off completely because of traumatic childhood experiences. While I was preoccupied with getting through the divorce, the lack of sexual variety was not a big thing. There was always the possibility that our sex life would improve once the divorce was final—unless the proceedings took so long that age would begin to take its inevitable toll.

Early in our partnership, Vicki and I found that the trust between us was extraordinarily strong, forging a bond which we hadn't known with anyone else, ever. We could reveal troubling thoughts, feelings and fantasies to each other with only minor anxiety. This helped us expand our sexual repertoire, with the uncertain partner trusting the other to lead the way. Before long Vicki was letting me go down on her, and enjoying it thoroughly. We shared long-forbidden, conflicted wishes for anal sex and began some tentative explorations, one finger at a time. Unsure but intrigued, we bought Jack Morin's book, *Anal Pleasure & Health*,* which was most reassuring. It was very informative (how very little we knew about our asses), and very helpful.

I had been stressed out for ten years, a sedentary professor for thirty, and a heavy smoker for forty. Still, when I had a serious heart attack I was taken by surprise—I'd been in denial. Dame Fortune smiled on me, and excellent care by good people, from the emergency room through heart surgery and a six-week outpatient rehab program enabled me to make major lifestyle changes. Within several months I saw the benefits of not smoking, a healthy diet and an exercise program. Two years after the heart attack I was in better physical condition than I'd been since my early forties. Conscious efforts to reduce psychological stress paid off. The divorce was over, although it took a while before the aftershocks died down.

After a heart attack one approaches any strenuous exercise tentatively, and sex is no exception. A bout of moderate post-hospitalization depression and the side effects of medication for high blood pressure further reduced my interest, and it

took the better part of a year before Vicki and I were getting it on again once or twice a week. But gradually, the flavor of our sex began to change. It was still basically vanilla, but more and more often there were swirls of strawberry jam mixed in, with occasional toppings of hot fudge and whipped cream. Going down on me became easier for Vicki, then almost attractive. We began to enjoy anal sex more and more. Each of us left ancient prohibitions behind, anxiety levels went down and gradually we got more in touch with the inner workings of our rectums.

Six months after reaching sixty-five, I could no longer deny that I couldn't count on automatically getting an erection in response to sexual stimulation. And when I did, the erection wasn't as stiff. Sometimes my penis went soft before I could reach ejaculation. This was it, I figured, a true sign of aging. Even though I looked and actually was healthier than ever, and my libidinal interests were as pressing as twenty years before, I had slipped into the sexual end game. I'd gotten Medicare, but what good was it? Free medical care for the impotent? In another year I'd be lucky to get it up once a month. I began to check the ads in my AARP magazine for anything that would help, but the prospect of vacuum pumps and injections was disheartening.

Faced with the distinct possibility of melancholia, my penis somehow found renewed vigor and responded at least half the time. Even when it didn't, Vicki seemed happy enough with oral sex, finger fucking and the vibrator. And I was getting off on her fucking me up the ass, although my orgasms weren't the same as those which came with ejaculation. They

were more like a wonderful swelling in the pleasure centers of mind and body, a generalized all-over-the-inside-of-the-body feeling, endorphins coursing through a whole network of channels all at once. Although the question had passed through my mind before, now it was loud and clear. Was all that crap they fed us about cornholing just one more curveball designed to keep us from discovering the joys of anal pleasuring?

The autumn that I turned sixty-six we took a two-week car trip, stopping at the Grand Canyon and a few other attractions in the west. Travel and motels always invigorated our sex lives, but after returning home this time we carried on as if we were still on the road. We had some form of sex five or six times a week, a phenomenon for which we had no explanation (nor did we waste energy trying to find one). This lasted until mid-December, when children and grandchildren arrived for the holidays. They were lots of fun, and we were only slightly disgruntled that their presence interfered with our lovemaking. Parenthetically, there was an abundance of libido around the house while they were here. The three grandsons are very attractive, entirely masculine, and had only recently entered puberty. Coming from a wintry climate, they were intent on playing basketball outside at the local playground every day, where their good looks and cool attitudes attracted a bevy of girls to the chain link fence outside the court.

After they departed Vicky and I realized that the idea of diminished sex after sixty was nothing but hogwash. At least it was for us, as our stored-up libidinal energies broke

through the dam and carried us downstream. True, after two long sessions of ardent love-making, the erector set went on strike. But the libido remained as intense as before and we got into our bag of sexual alternatives. A trip to the adult video and toy store was the first of a never-ending series of mind-expanding adventures. Vicki found an enticing strap-on dildo which sparked her not-so-latent fantasies of really fucking me up the ass. The dildo's length and girth inspired me to a new form of machismo. My ass could take just about anything the store had for sale. (It was anatomically fortunate that the larger items on display were outside of the fixed income budget so common amongst us seniors.) Subsequent visits to the store encouraged us to try new and unthought of adventures in plain and jelly rubber, clear lucite, resilient silicone, and beads, rings, harnesses and double dongs.

By now we had no doubts that sex after sixty was far better than our earlier experiences. We were having great fun, yet, a couple of months later my erections again became infrequent, and my interest in sex began to flag once more. Although my faith in physicians had never been very high, I sought out a urologist. To my delight, I found a man who was both human and encouraging. Although he had several alternatives for me to consider down the road, in order to find out more about my problem he gave me a shot of testosterone and asked me to subject my poor flaccid wiener to a shot of Caverject. To my surprise, the needle wasn't painful. I left his office, went home with a gorgeous erection and Vicki and I had intercourse for an hour and a half. Then, for the first time since I was a teenager, I went to the grocery store with a raging hard

on. After three hours my stiff member began to feel uncomfortable, and an hour later I started worrying. But the old boner relaxed before I had to seek emergency intervention, and the experience proved that anatomically there was nothing wrong with my ancient pecker.

About this time we started exploring the world of cyberspace. Libidinally driven (a testosterone injection once a month does make a difference), it wasn't long before we were into the worlds of alternative sexuality. B&D S/M was the first stop, and we became interested in role-playing, costuming, nipple clamps and floggers. One result was that, unlike the other retirees in the neighborhood, I had to keep my garage workshop doors closed. I wasn't inclined to answer questions about my interest in making fur-lined handcuffs and ankle restraints, cutting lengths of chains, and fashioning whips and floggers out of old belts and inner tubes. Our fascination with the world of B&D S/M continued for several months before we realized that while an occasional flogging led to a much-desired rush of endorphins, the cultural details of B&D S/M weren't for us. We could barely tolerate the piercings of our two older grandchildren, and what little we'd heard of industrial gothic music was too grim for a couple of old farts much more into living than whatever that was about.

The Internet expanded our shopping opportunities as well. That was how we found Good Vibrations, and we've visited the store each time we've journeyed to San Francisco. I'm well past sixty-seven now, and the only things which have messed up our wonderful sex life are outside interferences such as consuming problems with our children. And we're

still growing! Sparked by the Internet, we want to expand our eclectic sex life even more. For one thing, we've both become what they call bi-curious, and hope that some day we'll find just the right couple with whom we can explore some new horizons. (Now isn't that a trip for a confirmed old hetero-sexual from the Great Depression generation?) Meanwhile, with monthly shots of testosterone, my erections are frequent enough so that we rarely resort to penile injections (and now new oral medications are available). And so this elderly gentleman continues to be much more than happily retired. Within a wonderful relationship, I'm delightedly stroking and caressing, and joyfully plunging into whatever orifice turns us on each evening.

* *Anal Pleasure & Health, Jack Morin, Ph.D. (Down There Press, San Francisco, 1998).*

Getting Better All The Time

❦

Andrea Anderson

*A*few years ago my eldest daughter was surprised to discover I was still having sexual relationships.

"Mother!" she exclaimed accusingly. "Sex at your age?"

"Yes, dear, it's actually getting better."

This summer I will be celebrating my seventy-fifth birthday. My partner is seventeen years younger than I, which has presented no problems. Viagra is not for us in the foreseeable future!

Hugging and back massages are a pleasant adjunct to our relationship, as is stroking each other with a soft feather duster. We use candlelight, soft music and a great many pillows to make ourselves comfortable.

I enjoy running my fingers through his hair and having him rub my stomach with his head. He has a strong affinity for my breasts, which, due to long use of estrogen, swimming, exercise, and wearing underwire bras, have remained in good shape.

Sixteen years ago I had a full hysterectomy. Contrary to popular belief, it did nothing to lessen my desire or capacity for sex, but actually increased my relaxed enjoyment. For thirty years I have suffered from osteoarthritis in my lower

back and right hip, curvature of the spine and a variety of other physical problems. So my one-and-only partner for the past seventeen years and I have learned to improvise. We've experimented with "upside-down" and a variety of versions of oral sex—activities on which the religious right would undoubtedly frown. And we stimulate each other and ourselves with hands, mouth or vibrators. Occasionally I lie partially across his body on my back at a ninety-degree angle and he penetrates me from below. Sometimes I am on my knees and he enters my vagina from the back.

Adequate lubrication, during both foreplay and intercourse, cannot be overemphasized.

We hope to continue connecting until "our bones become too brittle to risk contact," as Alan Alda promises in the film "Same Time Next Year."

A Ruling Passion

ℰℛ

Stuart Greene

Some people have a passion for work, money, religion, or football. I have a passion for sensuality, for giving pleasure. I love sex, fireworks, Thai chilies, and absolute honesty; in short, I love intensity. I love taking chances and doing things that make me feel really alive. But sex—the taste, touch, smells of sex, which bring my lover(s) and me so many pleasures—is my ruling passion, a passion I enjoy and appreciate more and more as I age.

I might not be as free as I am were it not for the love of Kim, whom I met about six years ago. Kim is fifty-four and I am sixty-four. Like me, Kim has always had a sensual-sexual nature, though woefully repressed during her long tenure as a "Catholic housewife." Gradually we have encouraged each other to be who we are. She loves my body, loves walking around naked (as I do) and encourages (and often outdoes) my sexuality, delighting in the pleasure I and others give her.

I'm now pretty much out of the closet as a bisexual male, surprising friends both gay and straight. I love men, I love women, and all the beauties of the human flesh: cheekbones, breasts, nipples, lips, vulvas, clitorises, penises, buttocks, thighs, feet and toes. All to be touched, licked and pleasured.

Though my libido is still strong, over the years there have been substantial changes in my physiological sexual response. I have spinal osteoarthritis, and sometimes I wake up in the morning and hurt; my neck hurts, my back hurts, and I feel old. I get up, exercise, move around, check my e-mail and surf to a few favorite explicit web sites to stimulate my libido, which stimulates my love of life, my essential vitality.

Though it takes me longer to reach orgasm, and my output of ejaculate has diminished considerably, this does not impair my orgasmic sensations. Although my orgasms are less frequent than they were even ten years ago, they are often wondrous and shattering. I have to be quite physically ill and/or in great physical pain not to be interested in sex. But as with most people, my interest in sex and feelings about sex vary hour by hour and day by day. So I often create situations and fantasies to enhance my libido.

For example, I use explicit photos of consensual sex on the Internet. I also love going to a men's private sex club, and walking around naked, stroking my penis and balls while watching men of all ages, sizes and colors display themselves. In the past six months Kim and I have engaged in four threesomes, one of which was a delightful evening spent with a very sweet male-to-female transsexual.

Manipulation no longer has a place in my sexual repertoire. Honesty and curiosity are great turn-ons for both Kim and me. We have a fantasy of finding a compatible bisexual couple somewhere in our future.

I keep a sexual diary and would like to share some of my entries.

26 November 1998, Thanksgiving Day

A woman friend arrives at a party in a very friendly and touching mood. When she hugs and touches me, I find her attentions to be very stimulating. It puts me into a stage of early excitement and I can feel the blood flow into my pelvic area. I feel the flush and wonder if my face and neck are red. Later in the evening I find myself in the living room talking with another older man and the same woman comes in and lies down on the couch, striking a sensual pose. The other man says she reminds him of the Goya painting entitled "The Naked Maja." I say she reminds me of a Vargas painting, except of course, she is clothed. She thanks me for the admiration and immediately I have all sorts of fantasies about jumping onto the couch and pleasuring her. I know that I am breathing heavily and am probably showing a sexual blush

I am very sexual: In the past six months we have been to two pansexual pagan parties, one bisexual party and one swingers party. I do prefer the pansexual parties, where the only limitations on our sexual activities is mutual consent

Sex is such an important part of my life. I am physically able to be sexual and, therefore I do it as much as possible I would not want it to be any other way. Yes, I am a libertine and I'm quite happy about this

6 December 1998

Kim is very horny this evening since this afternoon she saw a woman friend to whom she is very attracted. She and I are similar in that talk about sex gets us aroused. I say: "I love

your beautiful vulva and especially like the sweet taste of your pussy." We fuck from the side with me on top and then I go down on her and then it's rear entry for more than 500 strokes and she comes and comes and comes. I do not come at this time, which is perfectly OK as I love getting this type of aerobic exercise

10 December 1998
Kim arrives after a long day and some extensive dental work and I expect little except some hugging. Instead she puts on this great purple velvet dress and comes in to kiss, hug and fondle me as I sit here at the computer. So we have one of those great quickies, which make both of us feel relaxed and satiated

14 December 1998, A.M.
Kim comes on to me in the bed; touching and caressing me. She licks and plays with my nipples, scrotum, balls, perineum, and penis; getting me all excited. So we fuck; her on top facing me; her on top facing away; rear entry at the edge of the bed. I ask can I put my finger into her anus and she says yes; equals great pleasure for her and for me as I push my finger(s) against my thrusting cock. Then I ask if she would like me to fuck her anally and, of course, she says: "Yes!" So it's on with the condom and penetration and thrusting as she makes those wonderful noises which signify pleasure to both of us. Then I pull off the condom and I'm back in her vagina with my fingers in her anus until we both scream with delight

19 December 1998, 5:30 A.M.
Received the following e-mail this a.m.:
hey you sexy boy —
sorry I woke you up just now
but seein' as how
we're both awake . . .
an I'm thinkin' of you
and you're thinkin' of me
even if you're a little angry
even if you ain't exactly
turned on at the moment
couldn't we . . . um . . . be
gettin back into bed presently
*as the Brits say, *presently**
whenever . . . you know, whenever we
get tired of tappin' the keys couldn't we . . .
get back into bed
and I'll surf your tummy
and lick your bottom
and suck your succulents
and maybe your engine
could search my web?
Needless to say it is back to bed for a pleasant early morning interlude

25 December 1998
At the Christmas party we went to there was a woman wearing a sweater/no bra and being able to get just the slightest glimpse of her body from neck to waist, I say: "That's really a turn-on." For a good deal of the remainder of the

evening this beautiful woman keeps rubbing her body against mine and giving me very sensual hugs; while looking deeply into my eyes and sensually kissing and touching me; none of it blatantly sexual, but very nice. Kim encourages her to continue this behavior. I am very aroused by this; never to the point of erection, but lots of very intense pelvic and mind feelings. I fantasize that we all fuck together

1 January 1999, 4 A.M.
Most of the night we've been enjoying a pansexual pagan New Year's Eve party. We arrive home, close to 4 A.M., drink a bottle of champagne, fuck some more and get to sleep by 5. All in all a very nice evening

8 January 1999
At the club I met Brian, a seventy-eight year-old guy from the suburbs, and he began caressing my body and I his. We moved into the glory hole area and he was touching and playing with my cock as I played with his. Even double-gloved my hand and penetrated him. He wanted me to fuck him, but I would not and he also wanted to suck my cock without a condom, which is another thing I won't do. Eventually he played and played with me until I came big time; noisy with lots of cum. The whole thing was very nice. I liked the attention that he gave me. Getting this type of attention is very important for me to become aroused. . . .

9 January 10 1999, early A.M.
Our houseguest leaves and we get very close as this is the first evening in a week Kim and I are actually alone to play around. Lips, wonderful lips, and tongue kissing arouse both

of us so I ask her to bend over a chair and we fuck for a few minutes until she has an orgasm or two. Then it's into the shower, touching and washing. She allows me to pee onto her body, which arouses both of us. Then into bed where she spends a few minutes sucking my cock and giving me pleasure. We do 69, then I really go down on her sweet pussy getting and giving pleasure with my tongue from all angles. When she responds to my mouth—that makes me very aroused. She tastes and smells so sweet. To the bottom of the bed where we fuck and me thinking that this orgasm I'm about to have is for a friend, who was never a lover, who has just died. What a wonderful orgasm it is, too

26 January 1999
Kim is reading this and chuckling. She looks up at me with such affection and says, "I love you so much." She kisses my hand, bites my index finger and asks, "What mischief can we get into tonight?"

Sparkle

ço

Rusty Summers

I am in my eighties and I still have a good sex life, though It's not quite as vigorous as in decades past. I have maintained my sexual activity, though diminished, through the following methods.

I try to live a healthy lifestyle, which I think is basic. I eat sensibly, I take nutritional supplements, exercise for fifteen minutes every morning; including some yoga and the Himalayan lamas "Five Rites of Rejuvenation." I also take a brisk fifteen-minute hike every morning; I swim at the nearby YMCA for fifteen minutes three times a week; and I use a hot tub or sauna every day. Finally, I take a teaspoon of concentrated cranberry juice in some water every evening. I have found that this keeps my urinary tract in good shape and I rarely have to get up to urinate at night.

On my doctor's advice, I inject testosterone in my buttock twice a month. In recent years I have added some safe herbal stimulants, such as *avena sativa* (wild oat extract) which helps to keep up my libido up. When engaged in any sexual activity, I also usually flick or massage my nipples, with the fingers of a free hand, to add an extra boost of libido.

I masturbate to orgasm, without ejaculating, several times

before going to sleep at night and before getting up in the morning. Immediately thereafter, I perform the Kegel maneuver, usually about eighty times, to massage my prostate and release the fluids and tension built up from masturbation. I learned of this procedure in *The Tao of Sexology*,* by Dr. Stephen T. Chang (Reno NV: Tao Longevity LLC, 1986). The author claims that masturbating by stroking the penis full length tones up major organs of the body (the heart, lungs, spleen, pancreas, liver and kidneys), while masturbating only on the head of the penis can over-strain the heart. He writes, "If you practice Taoist masturbation—that is masturbation without ejaculation—you can masturbate ten times or one hundred times a day without doing harm. In fact, doing so would benefit your entire body, because your entire body is energized uniformly when the entire penis is massaged."

It took some time for me to develop the control necessary to stop just before the point of no return to avoid ejaculation. The PC muscle is usually involved in not going over the top. But even with long practice, I miss once in a while—and sometimes deliberately. Yet, it is a great feeling every day to work up to many orgasms without ejaculating. This technique entails a period of partial relaxation between orgasms, usually a very brief time during which I can let the critical buildup somewhat subside, before stroking up to the next orgasm.

When I make love with my lady friend I cannot achieve multiple orgasms. When I do ejaculate, it usually takes a day or so before I can masturbate again to orgasm without ejaculating.

I feel fortunate that I have learned how to enjoy sex at an

age when, I understand, many men no longer have any sex life. I believe that it contributes significantly to my overall health and certainly to my feeling of well-being.

* *The Tao of Sexology, Dr. Stephen T. Chang (Tao Longevity LLC, Reno NV, 1986).*

In Limbo

⁊

Joe De La Torre

As I sit here writing, I am awaiting a prostate removal operation for cancer. While I am sexually active at the present time, I wonder and worry about what my sex life will be in the future.

The first thing the doctors asked is, "Are you sexually active?" They seemed to be surprised when I told them that I am indeed very sexually active.

I am sixty-four years old and I have no problem finding sexual partners, both female and male. It's not that I am especially handsome or rich; I can only attribute it to my personality and the fact that I am well endowed. I hasten to explain that I do not go out of my way to use this to my advantage. I have always wanted to be wanted because of myself and not because of my physical attributes.

I was worried about not being able to have an erection at my age, so I started taking Vitamin E, *gotu kola, yohimbe* and external administration of Minoxidil. My libido is not as strong as when I was younger, but I am still able to perform almost as well as twenty years ago. My body craves release at least twice a week, whether I feel the mental desire or not.

My sexual life takes different forms. I find that I am bored

with most ordinary sexual modes, so over the years I have sought out off-beat erotic ventures. These have included threesomes, swapping partners (having sex with both husbands and wives), and having partners of various races, genders and ages. I have gotten into s/m, sex toys, picture taking, and making videos. For a short time I could only get into sex if it was in front of a camera. It was not the results of the filming, but the process, that I found to be a turn-on. After a while I found that the thrill of the chase and the conquest were even more exciting than sex itself. Also, masturbation has become a primary interest, since I can fantasize any scenario and it will become "real" in my mind. In my fantasies, no one ever says no, and my partner will do anything that I want without protest. I can live out my most secret and intimate desires without regret or fear. So masturbation can be even more exciting and pleasurable than the more ordinary act of intercourse. In fact, with a partner I will often fake an orgasm and later will relieve myself by manual manipulation. This is something that surprises people—I have not heard much on the subject of men faking orgasms. I wonder if I am the only male who does so?

I currently have a male lover who I see and have sex with twice a week. I also have a female lover, and have sex with her about twice a week too. I also have sex with men who are strangers almost every week.

As I have grown older I have found that men tend to be more physically satisfying and women more mentally satisfying. Now I mostly seek out men for sex, and women for friendship.

I've had orgasms at least twice a week all my life—and I hate the thought that I might not be able to have an orgasm after the operation. But when you only have two options—to live a few years with a full sex life or lose sexual fulfillment and live longer—a longer life seems to be better than a few more years of sex and an early painful death.

Such Sweet Suffering

❦

Daniel Larsen

I remember reading years ago something ascribed to the novelist Somerset Maugham to the effect that one of the glories of advanced age was to no longer "suffer" from a sex drive. I thought that a description of pure hell: to be alive and yet have no interest in sex. The idea scared me. It still does. But it hasn't happened yet.

In our culture, we are squeamish talking about sex among older people. Hell, we're squeamish about sex among all kinds of people. But those of us who have enjoyed sex over the years fear losing desire as we get older. The possibility of losing it certainly increases as we age, but it doesn't necessarily have to happen.

I am sixty-six and married to a fifty-two-year-old woman. Joy and I are both professionals, both athletic and in good physical shape, which helps us to enjoy sex very much.

For instance, one night our ten-year-old son surprised Joy and me by going to sleep around 10 P.M.; he's a night person and is rarely asleep before eleven. He sleeps right down the hall from us, which somewhat limits our sexual opportunities. Taking advantage of the situation, Joy and I jumped into the hot tub, engaged in some mild sex play, then went up-

stairs, put on Van Morrison's "No Guru," and made love. Af-
ter about an hour, during which we enjoyed massage, oral sex
and intercourse, I had a couple of non-ejaculatory orgasms.
Then Joy sucked me to a wild climax. . . . I was in another
world, my feet up on the wall, my pelvis bucking like mad, Joy
holding me with hands and mouth, and cum flying every-
where. After my final orgasm, I held her while she used a
vibrator to have several orgasms herself. It was a wonderful
night, not that unusual, but not one that I would have ex-
pected to enjoy at this age.

I grew up in a sexually repressive family; maybe as com-
pensation I developed a strong interest in sex. It has always
seemed to me a skill to be developed. People don't think twice
about spending lots of money and time on sports or hobbies,
but it seems few are willing to spend time and money on im-
proving their sexual abilities. I don't mean just having sex, I
mean learning how to do it better. Now, in my mid-sixties,
I'm having really good sex. Better than when I was twenty?
That is a hard comparison to make, and probably not one
worth worrying about. It's enough that sex now is great.

Joy and I make love at least once a week, in a variety of
ways. Sometimes I concentrate on giving her pleasure, start-
ing with plain feather-light massage, as she likes—just
fingertips brushing over arms, shoulders, back, buttocks.
Eventually I'll get to genital stroking, and she may finally
bring herself to orgasm with a vibrator while I hold her. And
then I may masturbate to orgasm while she holds me. On
other nights we may do a lot of cuddling with her bringing
me to orgasm with oral sex. Sometimes that is satisfaction

enough for her. More often, though, we engage in a lot of touching, oral sex and intercourse—but not in a linear progression. We move back and forth from one activity to another until we are satisfied. Usually she will use a vibrator to achieve an orgasm, sometimes at the beginning of our lovemaking, sometimes later or at the end.

Joy and I have been married for fifteen years. She was not as orgasmic as she wanted to be when we married, so we took a trip to San Francisco and came home with a coil vibrator. Now she is almost orgasmic from stroking or oral sex but always orgasmic with the vibrator. We keep working on that—not too seriously, but it is in the back of our minds. She would love to have orgasms without the vibrator, but it hasn't happened yet.

Soon we began to use the vibrator on me, with the cup attachment. Joy seemed to like it a lot. She found she could coax an amazing amount of pre-cum out of me. The vibrator gives me incredible sensations, almost too intense. It takes a lot of control for me to have vibrator orgasms and not slip over into ejaculation.

The most enjoyable form of sex play for me still remains oral sex. Joy hadn't had much experience with it, and at first it made her nervous. We are both from a generation in which women did not grow up with a very positive attitude toward their own genitals. Genitals were "down there," just as the penis was always referred to as "thing," as in "He put his thing in me." At first when I gave her oral sex, she held her body very still, allowing the arousal but not really enjoying it. Now all that's changed—she is an active participant, moving her hips

and directing my tongue either with movements or words. She experiences mild orgasms during oral sex, with genital contractions and changes in breathing patterns, but she says they are still not as intense or complete as what she gets with the vibrator.

While she never comes close to orgasm during intercourse, she loves fucking, the feeling of fullness in her vagina. She wants intercourse even more than I do, and usually harder and faster than I—I like it to last longer. I love to do it for a half hour or more, changing positions and tempos, sometimes staying almost still. We compromise. Sometimes we have intercourse near the beginning of lovemaking, when my erection is generally firmer, and move from there to oral sex, and sometimes we return to intercourse at the end.

We have enjoyed anal intercourse three or four times. It provides the thrill of something different and taboo, but no advantages for us other than that. Joy has a tight, well-muscled vagina that provides all the stimulation I could want.

While we have wonderful sex, I think it can get better yet. Pornography is useful to me, if just to keep my pump primed while our son takes his time getting to sleep. Aside from being stimulating, there are things you can learn from porn as long as you remember it is fantasy. Its biggest failure is that it doesn't show much lovemaking between friends, which I suppose doesn't make much of a story line. My wife has little interest in it, but she has enjoyed some of the women-created Femme films. Today wonderful books on sex are available, and my sexual skills keep growing. In particular, the books by Barbara Keesling have influenced our lovemaking a lot. Read-

ing her books has taught us to slow down, to broaden our sensitivity. We make love now more as a whole body experience, not just with our genitals. We find it's fun to tease our way to the genital hot spots, and then away from them.

I have been multi-orgasmic for years, but when I was younger it was because I could ejaculate and keep on going and have another ejaculation. Now, in my sixties, I can still have two ejaculations within a short period of time, but I can't count on two erections. However, I have learned to control ejaculation so that I can have many orgasms without ejaculating. I still like to finish by ejaculating—that feeling of the semen rushing down the urethra is wonderful.

As we all know, erections are a big issue for older men. Mine are often not as hard as they were when I was younger, and don't stay firm as long as they used to (although when I wake up in the morning my penis is as erect and hard as I could ever want, which makes me think that its relative softness at night is due to fatigue and maybe wine at dinner). I've never had any really serious erection problems. I've had periods when I wasn't interested in sex and thus didn't have spontaneous erections, but those were either because I was depressed about something or distracted by work. I didn't worry about those periods and knew that those feelings would pass.

I'm easily aroused. A few minutes of pornography will get me hard, thinking of my wife's body will get me hard, a little cock-touching will get me hard. I've never needed help to get it up. I'm usually erect and wet before I even get out of my clothes, but choose to restrain myself until my wife is as ex-

cited as I am. Nowadays, I often use a leather cock ring to keep my erection harder and longer (it has the added attraction of holding my balls out so they are easier to rub or suck—those slippery devils have a way of hiding). It also excites Joy to reach down and find I have the cock ring on. Another way of dealing with a mercurial cock is focusing on whole-body sensations.

When Joy went through menopause her vaginal juices temporarily dried up, intercourse became painful and her interest in sex almost disappeared. Topical estrogen creams helped, and she no longer has problems with vaginal dryness. I don't think the occasional erection problems I've had or the painful intercourse Joy experienced for a while are any worse than problems younger couples go through.

Joy gets to enjoy as much kissing, skin contact, nipple sucking, finger stroking, and vaginal thrusting as she wants. We often enjoy lengthy 69, with first one of us and then the other doing most of the stimulating. I can orgasm repeatedly this way. She loves to feel my penis swell in her mouth and my herky-jerky movements when I orgasm, trusting that I'm not going to ejaculate in her mouth, which she doesn't particularly enjoy. And I love having my face between her legs, nuzzling her wonderful, sweet-smelling flesh.

All of the women I've had sex with have been too inclined to stimulate the head of the penis too much and the rest of me too little. Joy, no exception at first, is slowly coming around to the realization that I like her tongue everywhere on my body, and I especially like it everywhere from my tailbone to my pubic bone. She is getting better and better, using her

hands more along with her mouth, changing the dynamics more, so that she will go from a soft lick to almost sandpapering the glans. She appreciates now that the head of the penis is not just one big nerve but a thousand little nerves, so that the tip of her tongue running across it leaves a comet-like trail of explosions. She knows, too, that her hand stroking my wet cock while her warm tongue is prowling around behind my balls can be almost overwhelming. We have a mutual devotion to make sex the best we can for each other. Can it get better than this? Of course! We keep pushing the edge of what we're comfortable with, not every time we make love but often enough to keep things interesting.

I'm counting on the idea that my penis won't stop until I do. To make this possible, I stay in shape. I work out to keep my sex muscles (which are all my muscles) strong and flexible. At the same time, I try to stay sensuous—enjoying the touch of fabric against my skin, enjoying a stretch, enjoying beautiful women I see and the quivers in my penis they provoke, and using all of that to make me horny. So far, it has worked.

Seasonal Changes

✧

Bruce Eastwood

*I*am a soon-to-be retired professor on the faculty of a
Midwestern college, a human behavior specialist whose
primary areas of instruction have been in human develop-
ment and sexuality. Human Sexuality and Aging are two
courses for which I have written the texts used by my stu-
dents. As I write this I am on my way to being sixty-four
years old.

My wife Mara and I have been together for almost fifteen
years. We like each other, love each other, respect each other,
find each other attractive, and still enjoy sex together. The
frequency of our sexual sharing, which includes a lot of ca-
ressing and oral-genital contact as well as intercourse, has
diminished very little during our years together.

We each feel free to initiate sexual contact. Our desire is
almost always communicated non-verbally, usually through
touching or caressing. Sometimes when we are in bed to-
gether and Mara is lying in my arms, she will straddle my leg
and press her vulva against my thigh, or she will uncover the
upper part of her body and luxuriously stretch her arms out
to her sides or above her head. Since both of us sleep *au
naturel,* the message is clear: "I am yours!!"

Lifestyle changes have brought about changes in our sexual behavior. At the beginning of our relationship we shared a rather small house trailer with my wife's two daughters. Because privacy was at a premium, whenever possible we would take a motorcycle ride to a deserted farm a mile down a nearby country road. There we would throw a blanket on the soft meadow grass and enjoy the sun, the fresh air, and each other. Now we own a farm, have no children at home, and enjoy as much privacy as anyone could want—so it has been quite a while since we have made love outdoors in front of "God and everybody."

I encourage my students to avoid establishing sexual routines at the expense of spontaneity. And I try to practice what I preach. But Mara and I do have one ritual which we enjoy every week—Saturday night is our night for love. The dynamics of our ritual vary according to the season. During the summer, and on warm nights in the spring and fall, after I have showered and she has taken a deep and relaxing bath, we adjourn to the swing on our covered patio where we hold hands, drink wine, and either talk or listen in silence to the night sounds. We especially enjoy sitting through a good thunderstorm. When we are thoroughly relaxed by the wine and the tranquility of our sylvan setting, and the night air has cooled to just below comfortable, we go off to bed. There she will lie for a time cuddled in my arms before we begin gently caressing each other, slowly arousing each other to readiness. Sometimes our coupling continues at this leisurely pace. At other times our passion erupts suddenly and we hungrily explore each other with fingers and tongues before coming together explosively.

With a change in the weather comes a change in venue. We move our ritual from the patio to our living room where we have a wood-burning fireplace. Usually before our Saturday night supper, I'll lay up a fire. After supper, until about ten, we watch television together as the living room warms. Mara then retires to her bath and I bring her a glass of wine while she luxuriates in her bubbles. I have showered earlier so I take advantage of her absence to set up the living room for the rest of our ritual. I bring extra wood from the basement and stack it by the fireplace. I light our glass candles and arrange them around the room to enhance the mood. I turn off the house lights.

We have a hide-a-bed which I sometimes open, covering its mattress with a very soft quilt. Sometimes I'll make us a bed on the floor in front of the fire. Most often we sit side by side in our two recliners holding hands.

For several years I have been studying the adult film indus-try and I have a substantial library of tapes that span several years and countries. I choose one for us to watch. Sometimes we watch the film in silence. Sometimes we kibbitz, backing up a scene and playing it over so we can critique some aspect of the film, like the editing or the camera work or the music, or pausing in the middle of the scene to look more closely at some feature. Sometimes, especially with foreign language films, we will mute the sound and listen to classical music while we watch the action. This has proven to be very erotic. When the film is over, we are eager to create our own scenes.

I won't deny that I have experienced some changes in my sexual functioning as a result of getting older. My erections

are not as firm as they were when I was younger, and they take longer to achieve. Occasionally I will lose one in the middle of intercourse. Sometimes I cannot ejaculate, or after I ejaculate, I experience muscle spasms in the area above my rectum. Sometimes my legs cramp when I position myself a certain way. Although these events and changes can be upsetting to me at the time, I take them pretty much in stride. According to the research I have read on late adult sexuality, these problems are to be expected. The good news is that these occur infrequently and little diminish the intensity of Mara's and my enjoyment of each other.

I am looking forward to many more years of mutual enjoyment. Mara and I are both healthy and we work at staying that way. Both of us quit smoking years ago, and we are careful with our diet, work out regularly, and watch our weight. When the weather permits we ride our bikes, or walk in the woods or sail our boat. These activities, as well as our quiet times together watching television or reading or sitting quietly through a summer night, are as much a part of our making love as is our sexual sharing.

Follow Love's Path

ↄ

Sarah Breton

*W*hen my husband died after nearly four decades of a remarkable marriage, I wondered how I could survive without his warm loving body in almost constant proximity. Nights were the worst. We had always snuggled spoon fashion, each aware of every heartbeat of the other. All our lives together, asleep or awake, we were in intimate communication. Just before his soul and body parted he reminded me of the vow we had made to each other at the start of our marriage: "I will follow love's path wherever it leads me." A trustworthy vow, it had served us well. I was determined to continue to honor it.

The trouble was, that at sixty, all the men I knew and cared about were already enjoying their golden years with dearly beloved wives. The single men who were available—and there were very few—were either gay or unmarriageable for one reason or another.

I did have wonderful women friends who shared their affection generously with me, offering warm hugs and impromptu family dinners. One of these, a colleague of mine in her mid-forties, sometimes spent the night at my house to avoid traveling home after work. She was going through a

painful marital breakup, and during this time of transition, we became even closer than we'd been before. One night we were giving each other back rubs when suddenly our hands found their way to each other's genitals. An emotional explosion took place: volcanic, or, rather, oceanic, tossing us both wildly onto an uncharted sea. I adored her; she adored me. Over the next several years we became almost one body and mind, and our love empowered both of us to flourish and grow.

Sadly, a time came when she fell in love with another woman . . . and then I knew what heartbreak was all about. For days my heart literally moaned; I could hear its cries of pain, so much so that I finally put a tape recorder against my chest to see if I was imagining these inner sobs. The sounds were clearly audible.

Eventually I recovered from the loss. Then one day an old childhood friend dropped me a note. She had seen my name in a newspaper story and tracked me down.

Re-establishing our girlhood friendship was a wonderful adventure—but what is germane to this book is that we also became lovers. She died just three years ago, when we were both in our eighties, but not before we had shared more than a dozen wonderful years together.

The Personals

⁊

Freya Lang

The file of my letters needed a code name in the com puter so it started off as "The Personals." What if some-one else happened to read it? I'd never maintained a correspondence with someone in a personals ad before; the very idea suggested losers who can't connect with partners through normal channels. I added the "SxAF 60" (Sex After Sixty) later. And that became the story.

When it started, I was recently widowed, in my mid-six-ties, living in a new community, and so lonely I couldn't even recognize the symptoms. I subscribed to *The New York Re-view of Books* and had read ads in the back for years, slightly amused at the come-ons and insinuations. "Dutch treat," in-deed! Each issue carried at least half a dozen ads from older women who pined for "walks on the beach" and "candlelit din-ers." Despite feeling needy, I couldn't imagine writing an ad, much less answering one.

But I found myself reading the ads with closer attention to details. Because in my new location my mailing address was a post office box number, I could reply without revealing my exact whereabouts. One day I read an ad, circled it lightly with pencil—for easy erasing—and considered replying.

DWM, *59, attractive, humorous, concupiscent, believes there is more to life than increasing its speed, seeks sensual woman for friendship.*

Why did I answer this one and not some other? Most ads placed by men in their fifties and sixties specifically seek younger women. Male septuagenarians were out of the question as far as I was concerned—my own age prejudice showing. It was something about the way he'd explicitly stated "sensual woman" that attracted me.

My first letter got right to the age issue. (Why waste postage on a fifty-year-old male who wants a thirty-seven-year-old dolly but is too shy to put his real wish-list in an ad?)

Are we a pair? Perhaps so if you find older women interesting!

His reply arrived promptly, describing his educational background (from which I later gave him the nickname "Harv" when I'd keep a few close women friends up-to-date on my Personals ad friend), his interests, professional activities, etc. More to the point of "sex after sixty," he succinctly stated:

I find women of all ages interesting, and am well aware that the sensuality graph rises with age! I am sexually uninhibited and love to give and receive pleasure . . . my libido is frankly not appeased by masturbation.

A few more exchanges about our personal histories, literary tastes, and other intellectual trivia followed. After all, we were both NYRB readers.

I'd sent a fuzzy photocopy of a black and white portrait in my initial letter, so by the third go-round I asked for his photo. The next letter included the requested snapshot which

showed a youthful-looking, tall, lean man in shorts riding a bicycle. The letter also included another envelope with this explanation:

Like you, I am intensely visual, so I am glad to enclose a recent photograph. In the small envelope is the rest of me, in case your fantasy needs to be satisfied in that regard. I sent it in the best of humor, and hope you will not take it as an insult or threat.

Now, in reviewing a thick folder of correspondence (old-fashioned, hard copy type), I realize that the photo of his erect penis wasn't stapled to his letter. But the man-on-the-bicycle snap is. I'd torn up the penis picture and thrown it away. My reaction had been a mixture of surprise and shock, plus a bit of titillation. My response was meant as a cool dismissal; maybe a therapist would call it "denial."

I'd written:

Two aspects of your recent letter and enclosures strike me as worth commenting on: I found it surprising that a person who works and lives in a sophisticated visual world would select a mundane representational mode to communicate a sense of sexuality. Of the two enclosures, I was quite taken with the cycle pose . . .

His reply was polite and forthright:

I'm sorry if the photograph of my penis gave offense. Images of the human body and sexual organs are for me fascinating and beautiful; I have never regarded them as 'mundane' or pornographic. The fact that we are taught to revile and be embarrassed by certain of our parts has always struck me as the height of hypocrisy.

I found myself writing again, not because of the photo of his "body parts" but because of his tone of sincerity and openness.

I do appreciate your writing freely about your sexual nature; your style is forthright and candid. Besides, you're highly articulate and that is enough to motivate me to keep the conversation going.

His reply:

I'm going to suggest that we call a halt to the whole subject of penis interpretation lest matters get completely out of control! Suffice it to say, I am relaxed about my body and other bodies, but have considerable urges to give and receive pleasure.

By that time, we were four months into our letter exchange.

Our epistolary friendship continued to develop in myriad ways. Along with writing lengthy descriptions of our different lifestyles—mine bucolic, small town; his frenetic, urban—shared information about our past lives and affairs. What else do potential lovers talk about?

He queried me about my "sexual activities since your husband died."

I replied:

. . . that's a before and after dichotomy that's hardly to the point . . . in three years of widowhood I've had no sexual encounters that meant anything. Opportunities do not occur frequently . . . I have had a long friendship with a man somewhat older than myself; what started out over twenty-five years ago as an affair has mellowed into less passion and more annual reunion. Anyway, he's married; lives a

long distance from me.

I asked about other responses to his NYRB ad:

I can report a fairly sparse response from which I elected to meet three women . . . on the whole it was an interesting experiment. After all, I connected with you. I have not circulated a "penis pix" to others because they were all close enough to see the real thing . . . in our instance, I was mindful that the distance between us might be partly narrowed by a fantasy enhancer . . . Having described something of my own passion, I'd be curious how you deal with yours. Do you masturbate a lot, as I do? I agree that trying to deal with this in writing is less than satisfactory, but I like a challenge.

To which I replied:

Masturbation is an art I have worked at and practiced over a couple of decades.

Certainly, the layers of our onions were being peeled back.

The matter of over/or close-to sixty sex was a common leitmotif in our letters. In fact, the topic came to have the code, "SxAF 60", so of course I added it to my computer file. Then we hit on the fantasy of writing a book together to be called *SxAf 60*. I suggested he come to California for an editorial meeting. As the idea gained steam, he'd send clippings from *The Times*, reviews of new titles dealing with sexuality, to which he'd add comments.

Occasionally, I'd receive more erect penis photos, with wry comments about using them as art in the book we were thinking about creating. When he sent some drawings of female nudes with the note to use them in a *SxAf 60* chapter on

"Sexuality and Physical Aging"—they were straight out of a life drawing class with a twenty-year-old model. I wrote back:
 Worshiping images of youthful body types, stereotypical of youth-oriented cultures, is becoming outdated. The new ideal should incorporate graying, balding, sagging, bulging, wrinkling etc., which are inevitable with aging . . . That's why art in SxAf 60 which perpetuates youthful body types is unacceptable.

Often there were intimations of a rendezvous. "Your coast or mine?" became a catch phrase. He was in the process of buying a shared condo in a "trendy section of Miami Beach;" I wrote about the beauties of my Pacific location in northern California. He told me about his favorite hideaway islands in the Caribbean and I mentioned frequent flyer mileage that I needed to use before year's end.

The rendezvous in some romantic locale, though often mentioned, never came about. There were hurricanes in Miami and my house was filled with summer guests. We joked about "arm-in-arm beach walks," the typical photo of vigorous oldsters in *Modern Maturity*, and all other stereotypes of older or younger lovers.

He'd adopted the signature "Priapus" for his letters and left it to me to research the origins of the name. I discovered it was the god of procreation and personification of the erect phallus. So I sent him a membership card for the "American Association of Rigid Penises (AARP)."

The letter exchange continued. I wrote a short story about a woman who answers a personals ad and receives a photo of an erect penis from her pen pal. She shows it to her women friends over lunch and they all have different reactions and

advice. He lauded me for my writing talent and we continued to keep the ball in the air through winter rainstorms and power failures on my coast, snowstorms on his. All the while, we kept mentioning that rendezvous we would have someday in a warm, sunny paradise.

In the second year of our correspondence, there was a confluence of events in my life that spelled out it being time for a trip to New York: a meeting with an editor, a reunion with my long-time male mentor/lover, and a chance for a visit with a close woman friend.

"Harv" wrote that he was delighted with my plans to visit his coast. He'd put the date on his calendar. I managed to set up the editorial meeting for the first day since it meant taking a commuter train out of New York City—business before pleasure. The second day was confirmed for the annual reunion with Franz, my "old" lover—actually he's mid-seventies and still looks at me the way he did when we first met over twenty-five years ago. He said he could get away from his midtown meeting in early afternoon: "I cannot skip the lunch," he explained, "they have me sitting at the head table for the award. Besides," he added, "you've always liked sex in the afternoon."

But I didn't respond to his suggestion. Anticipating that the following day with "Harv" most likely would be for sensual enjoyments, I had already decided to have a day of city pleasures with Franz. So when he arrived at my hotel, I met him in the lobby dressed for an afternoon of gallery visiting. After our first greeting I told him how much I looked forward to our infrequent rendezvous.

"It's a very special treat for me to look at art with you as my guide," I said.

"Well, all right," he replied, giving in to my flattery. "There's a new show at the Whitney I haven't seen yet . . . maybe we'll come back here before dinner."

We didn't go back to my hotel together before or after dinner. The show at the Whitney absorbed us. Since I'd never been there we did the entire museum and left at closing time. Over aperitifs and then dinner he asked, "What about this man you've been corresponding with?"

"I don't know," I replied tentatively, "except that it's kept me busy writing when I wasn't able to work on anything else. I'm going to see him tomorrow, then I'll let you know."

The next morning I called "Harv." He said he had only a few hours free, in the afternoon, so it would be a good idea if I could come to his apartment.

I had the morning free to window shop on and off Fifth Avenue. It might have been at Saks, maybe Bloomingdale's . . . Wherever, in the aisle of one of those stores, I caught a glance at myself in a mirror on the counter of the cosmetic section. I was startled. Instead of turning away, I stopped and looked again. Who was that grandmotherly-looking woman? It couldn't be someone who was planning to meet a man for sex-in-the-afternoon! The salesgirl was asking me something. "Of course," I answered. "Do a complete makeup job on me. Give me the works."

Time was running short. I took a crosstown bus back to my hotel where I'd planned to change clothes before the afternoon appointment with "Harv." Standing before the sink, I

looked at myself in the mirror and decided to wash off the makeup. I combed my hair, put on a bit of lipstick, appraised myself in the mirror, shrugged, and went off to meet him.

I'm not used to city buildings with doormen and buzzers so our first meeting was somewhere along the hallway; he'd come out to look for me. I'd gotten mixed up and was looking for the number of his apartment in the wrong wing. It was reassuring to have our first meeting be at a moment when I needed to be rescued.

There we were face-to-face in his apartment. But I wasn't feeling any heated passion. Rather, it played out as a languid, sensual climax to what had been a glorious exercise in mind-fucking. We sat on the couch for quite a while catching up, like old friends. In time he began to undo the fastenings on the loose, cotton overblouse I was wearing. We both giggled, not nervously, more in amusement at the situation. He took my hand as we got up from the couch and went into the bed-room.

"The bathroom is there," he pointed, "if you want to use it."

As we lay in bed together, I noticed the sheets and pillow were all hues of blues and greens. I closed my eyes and imag-ined being on a tropical beach with lush vegetation overhead and turquoise water cradling my body. Then his hands were touching me all over. It felt warm and assuring yet exciting at the same time. I began to realize what wonderful foreplay our months of letter-writing had provided. No wonder I felt so ready for what was happening now.

He was stroking my breasts, then licking the tips of my ears, my nipples, my belly. With his fingers he gently stroked

my pubic hair; then probed further. I began to experience all the glorious feelings I'd always had with my older lover, with whom I'd always been a passive recipient. In time, Harv began to guide my hand to hold his penis; with his body, he was giving me a signal that he wanted me to go down on him. I suddenly flashed back to things I hadn't thought about for decades: My best girlfriend in college telling me that her mother had warned her that only prostitutes licked mens' penises . . . that had been the guiding intelligence in my growing-up years. But I also recalled something I'd read in the popular '70s sex book by Alex Comfort [*The Joy of Sex*] about older couples being able to continue enjoying each other sexually into their sixties and well beyond if they were able to adapt to each other's changing bodies.

"If you lick it a bit, I'll get hard enough to easily enter you," Harv suggested gently. The image that came into my head was an ice-cream cone; I was just a little kid, licking slowly, all around the sides so that it wouldn't drip as it melted. Then I tried sucking, at first tentatively, then with more vigor. I'd been a thumb-sucker; there's a lot of gratification from it . . . I brought myself out of that reverie and turned my attention to what Harv was experiencing. Following his cues, I realized that by teasing—sucking then letting go—the pleasure for me was more intense than I'd ever known when I was being more passive.

We climaxed together, with his quite hard penis firmly inside me. I'd put it there myself —an added new pleasure.

It was sex-in-the-afternoon, but of a kind that was a new experience for me, just as letter writing with a stranger had

been. I was glad I had plunged in and tried both. And now I knew that the photos Harv had sent were not fakes.

Afterward, there was talk about getting together for another afternoon meeting, although he was busy for the weekend and wasn't sure yet about Monday. He urged me to call when I got back from visiting my woman friend in the Hamptons.

But I decided not to go back to New York on Monday. I found I could get a bus connection directly to JFK and make my Tuesday morning flight. It didn't seem urgent that I hassle my way back to NYC for another afternoon of sex.

Franz telephoned the morning after I returned. "What happened on Thursday? Did you meet that man?" I thought about how to explain what I'd experienced. I groped for some way to capture the essence.

"It was sex without a strong emotional connection," I began. Still trying to find the right words, I said "But those months of letter writing released an erotic force of sensual energy in me. It's alive and well, and I'd like to share it with you. So the next time I'm in New York, I don't want to go to a museum with you; I want to stay in the hotel room."

"For sex-in-the-afternoon?" he asked.

"Mmmm," I said quietly, indicating my agreement.

In a few days there was a note from Harv. "Why didn't you call again?" he asked.

In time, I replied: "Next meeting, your coast or mine?"

I still hear from him: a postcard from Miami, a holiday greeting card from Paris, even more penis pictures. But he never suggests a firm date or place for a meeting. Occasionally

I respond on postcards with stunning views of my northern California neighborhood.

Among Friends

ও

Robert Perham

There's absolutely no doubt in my mind that I've had more sex in my sixties and early seventies than I ever had before, except in my forties and fiftiess, maybe, when Sandy and I met at Sandstone (me forty-four, she forty-six) and then lived together for ten years.

But my sixties were, even in my estimation, pretty sexually active. In 1993 when I was living in Pacific Grove, California, my partner and I were no longer involved sexually and she was getting ready to move into her new boyfriend's house. I was traveling a lot between home and San Francisco and occasionally attended sex parties with friends, but most of my experiences were one on one. I kept a journal in those years and recently decided to tally my sexual encounters. I had sex in that year (my sixty-ninth) 208 times, an average of four times a week. There were some weeks when I had no sex, and the most intense week included sex twelve times. In that year I had sex with twenty-one different people. Eighteen were women, three were men.

It would seem from those statistics that I'm a sex junkie. But I don't think so. I don't recall ever feeling I was ignoring any important aspects of my life for sexual glut. In fact not

one of my friends ever accused me of being too lustful for my own good. Nor do I feel I was ever "caught" or "hooked," or that my rich sex life got in the way of anything. I had the pleasure of sharing life's most intimate experience with many of my friends, all of us happy about it.

Speaking of friends, I've noted as I've grown older that I prefer doing it with friends. You might ask, "Shouldn't that be true of all sex?" Of course—but it's become obvious to me that I much prefer to get it on with close friends because not only can we ignore the age difference, if there is one, but we can share fantasies without fear of being perceived as weird. Sex keeps getting better and more exciting with each new experience. I guess you could say the same thing about any learning process, but when it comes to sex, I was misled as a youngster to believe that you fucked lovers but not friends. I've found that to be patently false. Yes, there is excitement in the zipless fuck, but at my age, nothing beats being with a good, imaginative friend. With a completely trusting friend (trust being the operative word), I can get into anything my fantasies create for me, while knowing I'm pleasing my partner as well, because a good friend will let me know. Such fun! If I stop to think about the zipless fuck, I realize how one-sided it is. Since I know almost nothing about my partner, I must be doing it to please myself exclusively. This is okay on occasion—hey, there's not much about sex that isn't okay. But if I concern myself with my partner, I can keep fucking forever.

I'm alive today because of my sexuality. I've always tried to stay in good physical shape because I know I'll attract partners. So I stay healthy. In fact, I'll state unequivocally that the

only reason I'm still hanging around is because I'm getting lots of good sex.

If I were told today that I was in danger of prostate cancer and that I needed an operation that would result in my impotence, there would be no doubt what I'd do . . . or not do. For one thing, I'm not into life extension. I don't care when I die. At seventy-three I can be that smug about it. I'm not even afraid of flying anymore. What a life I've already had! Everything else from here on out is gravy, and I'm going to stay if for no other reason than to wonder where my next fuck is coming from.

Physically I seem blessed. Almost every morning I wake up with a good woody. I've never experienced a slowing down of my ability to achieve erection. I have noticed in the last couple of years that I sometimes don't remain hard as long as I'd like, so I've started taking Muse (alprostadil) which helps my erection stay firm for about an hour. I never limit my sexual excitement for fear of going too far physically for someone my age. If it weren't for the inconvenience to my partner, I'd love to go out fucking—what a great way to go! But I'm frankly quite astonished at just how feverishly intense I can become and how long I can maintain sexual activity at my age. With a couple of my partners, we think nothing of discovering the sun's up after we've been doing it all night. The time flies by. I always feel refreshed after three or four hours of sex.

Ten years ago I had an experience that could have ruined my life. I developed Peyronie's, which is something every male should know about. It is one of the least-known serious

conditions among men. Let me describe it.

Suppose you have a penis you're happy with, as I was until that day in 1987 when I woke up to find the penis I'd known all my life was now radically changed and obviously in deep trouble. In fact, the erections I'd become used to for sixty years were never again to be seen. For all intents and purposes, the penis I have now is very different than the one I had before that day.

I was fucking Lois furiously from behind. In my frenzy, my long, straight penis came out and as I plunged again, the head of my cock hit her tailbone and snapped for an instant at a forty-five degree angle. The shock was akin to jolt of electricity, but my penis snapped right back and we continued fucking.

About a week later I woke, turned to get it on, and looked at my growing erection. I was stunned to see my cock distorted so much that it was painful to maintain my hard-on. And what a hard-on! Until now, my cock had been long, and comfortably round. Now, as I looked in horror, my cock was no longer straight. In fact, it was grossly bent and seemed to head in several directions at once, not unlike a corkscrew.

A week earlier when I'd forcibly bent my cock at a right angle while it was hard, I had torn the tissue where the snap occurred, about two-thirds of the way down the shaft. As it healed, scar tissue had formed, contorting my cock's shape and blocking the flow of blood into the erectile tissues. My penis took an upward turn that was extremely sharp for over a year. This made my penis much shorter, and there remained at the injury site a "floppiness": my penis would flop from side

to side at this juncture, even when hard.

So listen up, all you old men . . . all you men of any age. You can "fracture" your penis! Even though there's no bone there, you can still damage the tissues and cause scarring. Be careful! But don't panic if it happens. You'll still be able to enjoy sex.

I've heard that the older you get, the more difficult it is to achieve an orgasm. Well, I don't give a rap about that, and that may be why, or at least one of the reasons why I've become completely multi-orgasmic. I no longer need "squirt" orgasms. As a result, when having sex, I never really think about the ejaculatory orgasm. If it happens, okay, and if not it's still okay, because I'm so caught up in an orgasmic state. Anyway the "big one" isn't always that big for me. Most times these days, I have a hard time recalling whether or not I did ejaculate the night before. I don't think about it because I'm enjoying myself so much.

For that reason, I've come to recognize my woman partner's orgasmic rhythm a lot more. Some women can enjoy getting into an orgasmic state from, let's say, cunnilingus, and can remain in that state until moved to another sensation. It seems to me that most women are not as much into reaching any goal as they are enjoying themselves getting there. My women friends enjoy sexual moves simply for the thrill of each singular experience. If, along the way, they feel the Big One coming, they let me know and I continue whatever I'm doing until it happens. But I no longer concern myself with either getting there myself or getting my partner there. I do what makes her feel good and we both groove behind it in a veritable sea of orgasmic waves.

Through the years I've relished one particular fantasy that I still love. Almost every time I enjoy sex, with either a man or a woman, I fantasize that I'm a woman. Usually when I'm with a male lover I'm pretty blatant about my fantasy, acting it out and really wanting to be fucked. If I'm with a woman, I'm more subtle but often connect instantly because I put myself on the same wavelength that she's on. It's not until I actually penetrate her that I feel forced to think and act "like a man" (and I love it). Until then, however, I try my best to share my partner's sensations while ignoring my erection. Incidentally, by concentrating on sharing the experience, I've precluded any erection anxieties I might otherwise suffer. While fantasizing I'm a woman, I often prefer not to get an erection because I can play with my genitals, stroking them in a female way. The top of my limp cock becomes my clit and I can have very intense orgasms simply by stroking my whole genital area the same way some women do while pleasuring themselves. And wow! Then my orgasms are very female in that they radiate through my entire pelvic area, often becoming whole-body orgasms.

As a younger man learning how to become multi-orgasmic, I tried to minimize the effect of a "squirt" orgasm by refusing to help it happen. As I'd approach the inevitable stage, instead of boosting it along, I'd back off by relaxing everything. One thing I noticed was that when I was about to ejaculate, I "boosted" it, or did everything I could to create an intense ejaculation. I helped it happen by consciously strengthening the involuntary spasms with sharp Kegels that would match and strengthen each spasm. Then, when I be-

gan to refrain from helping my orgasms along, I discovered they were far more intense and radiating, and they lasted longer than when I tried to make them happen. Consequently, almost every time I have a big o on its way, I go into a tantric state where open-mouth moaning and breathing actually slow down the contractions and greatly extend the orgasmic process. That's when the sensations really radiate throughout my pelvis and I sound very much like a woman in the throes of incredible joy.

Keeping Sex Alive

❧

Annie Maine

*A*re you still doing it?"
That was the question my mother would invariably put
to me each time I traveled from Maine to Berkeley to visit.
She would shake her head in disbelief. "You are certainly
strange. Most women your age are so relieved not to have to
do it anymore."

Then followed the familiar stories about women who had
suffered in silence under their husbands' sexual demands.
"But you!," she'd exclaim in disbelief, shaking her arthritic fin-
ger at me. "You are so different. I can't believe it . . . coming
from someone like me," implying that sex was of no interest
and possibly even repugnant to her.

Although I was miffed by her looking at me as some kind of
freak, over the years I came to realize that this seemingly nega-
tive commentary about my active sexual life was a cover-up. By
asking the question, "Are you still doing it?" and hearing my re-
sponses, she had an opportunity to experience sex vicariously.

As age softened her resistance, I discovered that my
mother was in fact a very sensual person. Had she grown up
in a different time and place, she might have enjoyed sex as
much and as freely as I do.

Later in her life we talked about a lot of things. She asked a lot of frank questions. One night, with great amusement, we shared the fact that we always looked at men's crotches and wondered about where it lay and how big it was. She confessed to being attracted to men like Dick Cavett: clean, intelligent, and sexually unthreatening, like a sensitive son.

A few years before she died at eighty-six, she asked me if I saw fireworks or shooting stars when I had an orgasm. She'd read about it somewhere. That night, she told me her biggest secret. She'd never had an orgasm.

She felt it was her greatest failure, not to be a real woman. "When I come back, in the next lifetime," she said, "I want longer legs and to be more sexy." It was wonderful to realize that she was, indeed, her daughter's mother.

Well, Mom, I'll do it for you in this lifetime. And if you're still asking the question from wherever you are today, you'd really be shocked (or titillated, whatever your mood). Because at sixty-one, your daughter's still doing it. As a matter of fact, *I'm* even surprised. If someone had told me that when I was in my sixties I would experience more satisfying sex than ever, I would have thought they were being overly optimistic.

But it's true.

Of course, I know that I'm not the stunner I used to be. Twenty is twenty. Sixty is sixty. When I look at pictures of myself as a lovely young woman, I'm amazed. What's truly amazing is not the beauty *per se*, but the realization that I never felt beautiful when I was young. I was someone else's treat: my svelte lines, my youthful curves. I was too hung up

with insecurities and neuroses to fully appreciate and enjoy what I had.

Today, it's different. Like a well lived-in old house, my body is pleasantly worn. I have places that sag and creak, surfaces that are not so smooth. My paint is somewhat flaky. But despite all that and the inexorable pull of gravity, I feel beautiful and, at times, very sexy.

I'm surprised and gratified that I'm still juicy in the right places, that my nipples are still sensitive, and that I am still affected by a gentle kiss on the back of my neck or a hard-on nestled against my belly at dawn.

In the drawer of my night-stand I have a maroon silk bag in which my mother used to keep her nylons. In it are two vibrators, a pair of nipple clips, an erotic audio tape in a player with head phones (*Delta of Venus* by Anaïs Nin), a butt-plug, two pairs of latex gloves, and some Astroglide. That should give you a hint as to some of my activities. I'm not playing bridge.

This certainly is not what I had expected, because for a time there, as I was approaching sixty, I thought I had lost it. Sometimes a week or more would go by without a single thought about sex. I wasn't doing it. I wasn't even looking. I hadn't masturbated or felt anything resembling an erotic twinge in the area below my waist for a long time.

That scared me. I thought, "Okay, this is it. This is what they told me would happen. I'm becoming a dried-out old woman about to be sentenced to a sexless future among the polyester fuzz-heads of the world!"

For someone like me, for whom sex has always ranked as

one of the ten best things to do in the world, this prediction was the dawn of hell. I was to be exiled from the Sexual Olympics forever. It was already happening. I remember clearly when men no longer looked at me in "that way." I had become a spreading middle-aged woman. Sexually I had become invisible.

I hated the feeling. It sounds superficial to be so caught up in it, but to lose my sexuality really made me sad. Maybe if I had had a steady mate through all those years, it might have been easier and more tolerable to let my libido slide, as couples often do when they age together.

But I didn't, and until my late fifties I was having a pretty active and interesting sex life. After a congenial parting from the father of my children when I was forty-five, I began a journey into sexual independence. As lovers came and went, I learned a lot about myself. At fifty, I lived alone, without a mate or steady boyfriend, for the first time in my life. It was an enlightening experience. I just wish I had done it when I was twenty; I could have avoided a lot of stupid mistakes.

Regrets aside, I explored and experimented with my sexual needs. The biggest realization I had during this time was that my body was mine to enjoy when I wanted to. It wasn't just a decorated Christmas tree waiting for a man to put in the plug before it could shine.

But when I approached sixty, things began to change. I began to lose confidence in myself sexually. In our youth-oriented society, I felt that at my age, I wasn't supposed to be sexual anymore. (Let's face it, except for the occasional formidable Olympia Dukakis, one rarely sees passionate eld-

erly lovers embracing on the street or in the media.) I was beginning to feel grotesque.

But I was determined to hold out, so I set myself into action. For openers, instead of buying into the uncomplimentary images we have of elderly women, I zeroed in on others, like the widows that the hero in Kazanzakis' novel *Zorba* used to woo—those very alive elderly women who danced with him in candlelit rooms, holding their portly bodies as precious cargo, their wrinkled faces blurred in bliss. That was the mirror of the future I held out to myself whenever I felt beaten down by chronological reality.

I entertained myself with at least one sexual activity a week: I masturbated regularly. I collected and read erotica. I adorned the walls of my study with pin-ups, Michaelangelo's "David" being among my favorites. I made regular visits to my neighborhood store, Good Vibrations, to browse among the enticing merchandise, just to look, feel and be a part of things. Here, finally, was a place where nobody looked askance at a sixty-year old woman renting porn films, asking advice about the best lubricants, and buying sex toys.

Despite the predominance of a younger clientele, I went to clubs or bars where pheromones filled the air. I danced as much as I could. Sometimes, no one would approach me and although that was painful, even embarrassing, I kept going. I was certain that staying at home in bed with a good book on Saturday nights (although there's nothing wrong with that) would be the instant sexual death of me. I wasn't looking to "get laid" *per se*, but I wanted to be part of the action, to be somewhere where it was happening. After all, sex is like a

muscle: If it is not used it atrophies.

Then one night about a year ago I met someone special. He saw me dancing alone and picked up on my sensuality. My age (I was ten years older) didn't even come into play. He looked, he saw, and he conquered. Now he is the delighted recipient of all the nurturing and sexual freedom that I offer as an experienced woman.

He is undaunted by my sexuality and never feels it's inappropriate. He is sure of himself and does not shrink from my passion. We enjoy each other with mutual glee. With no fear of being thought of as "overly demanding," I can ask him to make me come whenever I want, not just once but as many times as I want and however I want it. No more hang-ups about vaginal orgasms. Any old way is fine with us. He has a great tongue, a slow hand, a beautiful dick, and a loving pair of arms. The years of exploration and determination paid off.

Being older lovers has its consternations, as well as its comforting hilarity. The affectionate little run-ins during the night as we pass each other for yet one more foray to the bathroom—his frequencies due to an enlarged prostate, mine from a weak bladder. Who knows . . . who cares. We exchange greetings and hugs as we scurry down the hall.

Some nights I have to extricate myself from a passionate embrace because I've forgotten to take my hormones and I know I'll be plagued by insomnia if I don't. And then there's the partials. What do I do with them when my lover's staying overnight? My gums beg for relief, but I worry that romance will be threatened if he should wake up to a partially toothless wonder.

As with everything else, we work things out with humor and mutual consideration. We've come to realize that with the deep love of softly maturing people, these things aren't that important anymore.

We realize that we're not perfect and that not being perfect is okay as far as sex is concerned. It's not how we look on the outside that counts, but how we feel on the inside. The deep understanding and ease we give to the act comes from years of experience with our bodies. Sex is about enjoyment; it's not a performance.

I don't expect my partner to have a full-blown erection every night for hours on end. (Men are so relieved when you tell them that's okay.) I enjoy and encourage what's there. I find and play out the secret fantasies that turn him on. We embellish the central theme of penetration with oral sex, mutual teenage-perfect masturbation, and lots of stroking and hugging.

It now takes both of us longer to come. Sometimes neither one of us does before we fall into blissful sleep. Our lovemaking is a meandering trip. It can be started, and stopped, and resumed—in no particular order, with no particular goal.

(I can just hear the young people reading this, saying something like, "Oh come on. This old people's sex thing is all a big lie. Give it up. There isn't anything as satisfying as getting banged away at for hours on end by a hard ramrod-like dick with everyone coming all over the place." Well, there comes a time when that scenario isn't the only thing that makes your body happy.)

Whatever it is, I know it's good for me. Making love is better than wrinkle cream. It brings color and vitality to my

cheeks. Orgasms are anti-carcinogenic, as Wilhelm Reich re-alized many years ago. Sex is great exercise. It makes my heart beat faster and pumps new blood into my system. After snug-gling with my sweetie, I emerge from the bedroom looking, and feeling, at least fifteen years younger . . . and there's defi-nitely nothing wrong with that.

As Einstein said, "The tragedy in life isn't that man dies, but what dies in man while he's still alive." So don't let it die. I'd advise all women who are worried about their sexuality as they age to shut out the negative chorus of outside voices that tell them it's wrong, and concentrate on their own desires. Keep your sexuality alive and it will keep you alive.

Clean Old Man

૮ઝ

Steve McDonald

I live in senior housing and do volunteer work at other senior residences. What is this idea that you have to stop having sex when you reach a certain age? It can be even more fun when your arthritis acts up. Wow, it took us two hours to get all of our clothes off! Or, we had to do it twice when we couldn't get out of the tub. The urge is always there. Just like bicycle riding, we do not forget. In fact, as we get older we may kick ourselves, regretting things we did not try earlier.

Right now, at seventy-one, my life is great, and sex has never been better—nor as frequent. I have sex at least every other day and am positive that's why I have energy like crazy. Some mornings, I could explode with good feelings. I get on the bus bouncing out "good mornings" to almost everyone. Don't you feel just great when you've had good sex?

The term "Dirty Old Man" is terrible. I feel cleaner when I've had good sex; when I don't have it I feel dirty. I am sure older men and women could show some of the younger ones a thing or two. I was just thinking . . . let's say I do it just twice a week. That is 104 times a year, ten years is 1,040. In fifty years 5,200. So get in there and get your share!

I looked over the list of tenants where I live and tried to

guess who might venture into a sex shop, but I couldn't imagine any of them doing that. We had a safe sex lecture where I live and I've never seen such bored people. They never did get the condom on the banana. By the time the leaders explained what the condom was (in four languages), everyone was totally confused. They didn't even bother to pass out condoms.

Bravo to the places and people that are helping to make sex the good, healthy, fun and joyful thing it is; that is, until some dried-up, pinch-mouthed, warp-brained, narrow-minded weasel twists and gnarls the facts and makes it nasty.

Years ago in Oregon, I taught art classes at a rest home. Two people wanted to do something they had never done, so I said I would guard the door while they went into a large janitor's closet. Soon they were screaming for help. Somehow he'd gotten her legs up over the chair back and she'd gotten a cramp and couldn't move. Fortunately I was able to "rescue" them before any one else took notice.

My former partner George and I spent forty-three years together before he died. A lot of same-sex relationships last a long time. I'm positive that gay people of both sexes are tuned into something special sexually. When I die I will be cremated and my ashes will be put on top of George's in a California military cemetery. Although it might shock people, I sometimes say, "I will be on top of George, even in death."

People in senior housing do not make as many open remarks about my sexuality as they used to. A few years ago a lady at the elevator said, "I know about you, one bed, two men . . . shame on you." One woman said, "gay!" so I coughed on her. She asked me why I did that, and I told her, "Now

you've caught what I have; you will be a lesbian in two weeks."
Still doing it? It's like eating peanuts. Why stop now . . . ?

Vintage Sex

∾

Lin Stevens

Rain hits the windows. I draw the drapes, light a fire and
stare at the flames. I feel forlorn, lonely and tired of living
alone; of waiting for that special man I long for. But by now a
knight my age will not sit so proudly on his horse any more and
the horse will be age-worn as well. Still, it doesn't stop my yearn-
ing. Today I feel that I need to end this fruitless longing and
openly declare my desire for a man. What have I got to lose?

I draft the text for a companion-ad and mail it to the local
paper.

When my sixty-fifth birthday came close I lost heart be-
cause on that day I suddenly would—without any choice of
my own—belong to that gray wave of the population labeled
"seniors."

I had succeeded in accepting the gradual change from
middle-aged to older woman. But to be severed from one's
former identity between one day and the next was a threat.

When I turned sixty-five, I looked in the mirror to see if
my appearance had changed. My eyes were still blue, my nose
was still straight, the color of my hair still blonde. I turned
sideways to inspect my figure. Still a bit of a round back. Too
bad that hadn't changed.

I swapped a frown for a smile. Happy birthday, girl. You don't look too bad. And don't worry: You're not too old for love, ever.

At that moment I vowed that I would do anything to find a compatible man.

The paper with my ad is out and the first replies arrive. Most of them are from lonely men who are more in need of a nurse than a lover. Interestingly, one is from a man who lives close by. I call and we decide to meet at the beach.

The tide is out. Pale blue water stretches from shore to distant mountains. The sky is decked with transparent clouds in hues of pearl-grey and crimson.

My date, a man carrying a pair of binoculars, the sign by which I would recognize him, walks toward me.

He is short with a thick-set neck. White hair and a white beard frame a rosy face. With a contented smile he looks at me with the bluest eyes I've ever seen. The sapphire magnets draw me close. Our eyes interlock. We shake hands. His name is Albert. Then he turns around, points at a log and asks, "Shall we sit down for a while?""

He opens his backpack, takes out a thermos and offers me coffee. With measured movements, he pours the liquid into a cup.

"Do you come here often?" he wants to know.

"Oh yes, only not this early. This is an exception, really," I say, and explain about the manuscript I'm editing.

"You wrote a book?" he cries incredulously. "What is it about?"

It is the first time that a man has shown an interest in my

work on a first date.

Albert is an archaeologist. I detect a sadness similar to mine, when he says that he is retired but in search of an outlet for his creativity. "I'm doing some volunteer work now," he says. "I read books for the blind on cassettes."

Our meeting is so pleasant that we agree to meet again. About to part we walk to my car and, neither of us knowing what to say next, we wish each other a good weekend and turn away.

I open the car door, turn around and call after him, "Enjoy your day."

Swiftly he returns, raises his arms joyfully and kisses me fiercely. Warmth pulses through my body, heat spreading to my belly.

Albert invites me to watch the yearly fireworks from the roof terrace of his apartment. Excitedly I speed toward his home and we climb the stairs to the rooftop. Most of the apartment residents have come upstairs to watch as well. Albert and I stay back and press ourselves against the brick wall. The first flares go up, followed by streams of multi-colored light exploding in the dark sky like gigantic sea anemones in orgasmic splendor.

As I sigh in awe, I feel how Albert's hand slides around my waist, slips under my blouse, touches my breast. Excitement stiffens my nipples.

I follow Albert to his bedroom and while fireworks still color the sky and explode with spectacular thunderclaps, he mounts me promisingly, ejaculates prematurely, rolls off me without a sigh or sound and falls asleep.

My publisher's contract and the promised advance on my

royalties have arrived. Gone is the fear of Alzheimer's, memory loss and old age. Day after day I write and see less of Albert. With my still colorful imagination, I had conceived him to be a more sensual, more experienced lover. Did he perhaps feel my criticism? I haven't heard from him for a while.

When a long weekend comes around Albert calls. The yearning in his voice stirs my blood. He asks if he can come over.

"Albert," I shout, happy to see him again. With outstretched arms we reach for each other and kiss passionately.

"Let's lie down," I propose with renewed hope. Impatiently, I all but tear off my clothes. Frenzied with lust I caress him, play with him, straddle him, and my pussy, wet and willing, envelops his cock before it can wilt. His erection is stronger and lasts longer this time. Fervently I ride him, slowly at first with soft strokes, then faster, wilder

Like a pasha Albert lies back on the pillows, a heavenly smile on his face while I arouse him more ardently, diligently. Will he touch me a little? Take hold of my hips to set the pace? Kiss my breasts, hanging above him like fruit for the picking? But Albert just lies there, arms limp at his side, a smile on his half-open mouth.

Suddenly he drools and a dribble of saliva on his chin suggests that he is on his way to let go. A moment later, a trickle of semen between my thighs confirms the fact. His instant snore immediately after indicates that he is satisfied indeed.

I get up and flush disappointment down the toilet.

I've done a lot of writing but now I'm tired of working in solitude. I long for the caresses of a man. Crave sex. Passionate sex. The fire in my belly burns full heat. Desire cries for

fulfillment.

Once again I'm faced with the question: how does an independent older woman meet a man? I don't go to a church, a bar, a laundromat, a bridge club. Where can I meet like-minded souls? Do they all have partners or are they dead? Statistics show that women outlive men by fifteen years.

Perhaps I should place another ad with a different text.

I proceed with writing the ad and tack it on the wall. There! The declaration of a marathon runner in quest of love.

Among the replies is one that catches my attention. I pick up the receiver, dial and ask for Larry.

The man sounds pleasantly surprised and answers my questions in a warm, deep voice.

I ask where he lives. "In Vancouver."

Does he live alone? "Yes, I'm divorced."

"Long ago?"

"Two years."

"Do you have children?"

"Four."

When I ask what moved him to respond to my ad, he discloses that it is out of loneliness. Most of his life he worked in the States. Only recently did he move to Vancouver where he does not have any connections as yet.

The ease with which he acknowledges his vulnerable state surprises and gladdens me. I'm equally surprised by the questions he asks me. They reveal an interest in me as a person and are so unlike the information other men had requested in an effort to calculate my worth as a housekeeper, cook, perhaps a duplicate Florence Nightingale.

Larry's voice caresses and hugs. It is the voice of a caring man. Of a man who has whispered in a woman's ear and conquered her.

At the end of the conversation he mentions that he would like us to meet but warns me that he is a little on the heavy side. Airily I brush his concern aside and assure him that physical beauty is mostly irrelevant anyway. Thinking of my stooped posture and my wrinkles I confess that I am far removed from beauty.

"Let me be the judge of that," he replies.

Larry rings the doorbell. Filled with anticipation I run down the hall to meet him. The elevator door opens and . . . oh my god! Stunned, I look at a mountain incarnate filling the doorway.

In a daze I offer my hand to greet him and force a smile. He glances at me furtively, looks down to watch his step and waddles across the threshold. As we walk the now suddenly endless hall to my apartment, I attempt to convert disillusionment into acceptance. Behind me I can hear the man's labored breathing and, with every step he takes, the wooden floorboards creak.

I open the door to my apartment. A massive mound of flesh stands in the center of my room. Motionless he stands there, his arms lamely at his side.

"How pretty," he says, as his gaze wanders around the room and rests on the candles.

How pretty. . . . Two words from the mouth of this colossal creature, uttered with the wonderment of a child. I try to familiarize myself with the size of this huge man, but it is

impossible. I know that I'll have to let go of him as soon as I can, but my fear of hurting him struggles with my revulsion. The fear prevails and I invite him to have a seat. He places his hands, knuckles down, beside him and lowers his body with utmost care as if to protect the sofa springs. Once he sits down, he smiles with relief. His eyes carry the look of an expectant child, ready for play.

His smile, oh, his smile Only half a denture covers his gums. Quickly I avert my eyes, but it is too late. The picture of a collapsed fence, half of its slats missing, has already imprinted itself on my mind.

I force myself to look at him again, open myself to his sonorous voice and to the comments he makes about my books, my plants and my living room. "It is big . . . You have a beautiful home."

He asks what I do when I'm not writing. I must have said something funny for unexpectedly he breaks out in laughter and I watch his jagged upper denture sliding down. Almost instantly he catches the denture midway through its downward slope and pushes it back into place with his underlip. The maneuver betrays frequent repetition; the smile must have been broken a long time.

Anxiously I wait for a propitious moment to deliver the message that we'll not meet again. I feel shame that I reject him on account of his appearance. As soon as there is a pause in the conversation, though, I tell him with greater calmness than I feel that I don't want to meet him again.

Wide-eyed he stares at me. "Would you tell me why?" he asks.

"You are not really what I had hoped for or expected," I confess.

My visitor freezes. The earlier enchantment on his face curdles before my eyes, leaving little clumps of forlorn flesh hanging on his cheekbones. He looks at me in disbelief and says sadly but gently: "That's a pity . . . you are so much more than I had expected." Resolutely he places his hands beside him on the couch to get up.

Pity, guilt, shame, overtake me. In an effort to ease the pain, I offer him a cup of tea but he declines. "No thank you, I'd rather leave right now." With a sigh he pushes himself up, gets on his feet and staggers to the door; a wounded bull, too proud to die in the presence of his toreador.

My conscience gnaws, reproaches me for rejecting Larry, someone who has no friends, no work, and who lives alone in a new environment.

Two weeks later I phone and learn that he is still without work.

"I'm so happy you called," he says and asks if perhaps we could be friends.

I explain that my manuscript has to be on my publisher's desk before the end of the month and ask him to be patient.

Larry promises to wait, but still without work and with time on his hands, he calls every day. Frequently more than once. He inquires how my work is going, listens attentively, encourages me, lends his support. His interest is dear to me, but the frequent calls are, nevertheless, an interruption of my concentration.

As the days go by and the pressure of work accumulates, I

ask him to call me in the evenings only.

Inevitably, though, the day arrives when I need to work in the evenings as well; at times until deep into the night, and Larry's calls have become an imposition. My responses are curt and grumpy.

"You know what we should do?" he proposes. "From now on I'll stay up until you are finished. I will not go to sleep until you call and tell me that you've quit working, that you are in bed, and that you really have time to talk."

Larry's proposal motivates me to bring the work to an earlier halt. Leisurely our conversation floats across the border between midnight and early morning. In my bedroom, still and serene, only Larry's voice reaches my ear and touches my heart. I notice that fondness for him is taking root.

My book is finished! I send the manuscript, registered, airmail and special delivery, to the publisher. Now I'm free to meet Larry.

I wait for him in the doorway. The light in his blue eyes touches me before his arms do. With lips pressed together this time, he smiles shyly, almost mischievously; we know each other by now. With a decisive swoop he takes hold of me and presses me against his big, earthy body. Close, tight, endlessly. I do not resist. Revulsion dissolves in the shelter of his embrace.

He stays overnight. I yield to my desire for passion and solace and open myself. He lowers his heavy Buddha frame over me and his laboring, hungry thrusts fill me. I spread my legs wide to encompass his girth. My thigh bones grate in their sockets. My pelvis is about to crack. Gasping for air I

wrench my knees between our bodies and push him gently up and away.

Relieved of his weight I feel so deliciously light all of a sudden, that I boldly swing my legs over his shoulders and let him enter me deeper still. He rides me like a horse. With a shudder and a moan his body convulses while he holds me tight and cries, "My god."

Larry's prospects for work are good. He has to go on a business trip and calls me every day. In that deep, warm-toned voice, he expresses his yearning and tells me that he will be back soon.

The sound of his voice has bewitched me. I yearn to be with him, to talk with him, to lie down with him; in his arms, safe, protected, caressed, until he raises my head and kisses that tender spot in my neck, signaling the beginning of our mating dance. At the thought of his touch, my nipples stiffen and I get goose bumps.

If only he were here now, I would press my body against his. I would feel his hands slide down my hips, fingering my skirt to check whether I did or didn't wear panties. My hands would stroke his silky hair. I would kiss his eyes, his nose, his cheeks My lips would search for the mouth I was so repelled by before I'd tasted the sweetness of its kisses.

Each time Larry calls, his dear deep voice sings in my ears, reaches my heart, stirs my womb. My legs turn to jelly, my mouth is dry as a cork, my heart skips a beat and a drove of butterflies somersaults in my stomach.

On the days when I am alone, I write and feel at peace, but as soon as I hear Larry's voice, I go crazy. Gone is the writer, the therapist, the independent woman. Her strength and in-

dependence are hit by a tornado of desire. What remains is a woman with fire in her belly.

Tomorrow Larry will be back. He calls one more time and confesses with a chuckle that he gets aroused every time he hears my voice. "You are magic. With thousands of kilometers between us, you manage to get me so excited that . . . "

"Do you know the lightest object on earth?" I ask.

"No . . . what is it?"

"Your cock! It can be raised by mere thought."

"Sexy devil," he laughs.

Larry is back and on his way to see me. The door is hardly open and his arms are around me already. I take his hand and lead him to the freshly made bed. Hungrily we undress and press flesh against flesh. His hands grope for my breasts. He kisses my nipples. "Ah . . . How I've missed my little girls. They sure are excited, aren't they?"

There aren't enough hands and tongues to feel, to taste and kiss. My mouth takes in his sex. Slowly I lick, smell and suck.

"His majesty is saluting you," he sighs blissfully. Gently he pulls me up, takes my head in his hands, draws my face close, kisses me fiercely and asks with a quiver in his voice, "Is the princess ready for a visit?"

"She's waiting."

Larry knows that it makes me happy to please a man. But he also knows that, in the past, I often failed to climax. My desire to satisfy men's hunger knew no bounds. To be the source of their delight was a joy to me. Proud of my prowess I welcomed every opportunity to enthrall a man. But I never dared to ask for the time or the caresses it would take to meet

my needs. Stubbornly, I maintained that in giving men pleasure I was pleasing myself.

On his next visit Larry says unexpectedly, "This time I don't want you to do anything for me. You just relax and let me take care of you." Gently he puts me in the position he wants. Expectantly, yet anxiously I let him. His kisses, warm and moist, cover every part of my body. He kisses, bites and sucks the delicate spot under my chin. Lovingly he cups my breasts, raises them to his face and kisses the warm flesh. My nipples plead to be sucked and Larry sucks them. My body quivers.

Softly he strokes my belly, makes circling movements with his hands, around and around, so softly, so rhythmically, that I all but go into a trance. But not for long, for as he tickles my navel with his tongue we laugh like two kids playing.

Suddenly he kneads my thighs with firm strokes. My legs tremble. Larry moves down and takes my feet in his hands, kisses and sucks my toes one by one, slowly, as if tasting the most delicate morsels.

My longing reaches a pitch and Larry knows it. He spreads my legs and strokes the inside of my thighs, slowly, sensually, moving closer and closer to my place of pleasure. I can feel the lips of my sex swelling to a little mouth that begs to be filled.

Gently Larry opens my moist lips with his fingers and looks. My excitement mounts rapidly. I am almost ready but still I feel anxious that there might not be enough time; that the fulfillment, so close, will escape me.

Larry senses it and whispers: "There is no rush We have lots of time We can be together like this all night."

He bends over me, parts my now wet lips with his tongue and touches them with long, soft strokes. My body quivers, undulates. With arched back and raised hips, I beg for deliverance. And Larry fills, frees and releases the orgasmic woman in me.

Savagely my body convulses and with a scream I come.

Larry puts his head on my chest and rubs my belly tenderly. "There, there," he hushes. "See, you can have what you want."

When it's time for him to leave he says, "Shall I tell you something?"

"What?" I've learned to ask, so that he can be assured of my attention and curiosity.

"I love you," he says, hugging me closer than ever.

"I love you too More than I can say."

On the way home, a truck crashes into Larry's car, killing him instantly.

Preserving my memories of Larry, I mourn long and deeply. I want my body to be his again, untouched by other hands, but the desire to hold and be held, to kiss and be kissed is stronger, and a year after Larry's death, I grow increasingly more aware of the fact that I can no longer count on finding a permanent mate. By now, the differences between me and men my age are too marked. At fleeting moments I consider having a relationship with more than one man, but a voice in me nags, "Don't you think that's a little odd for a woman going on seventy?"

Yet, when the telephone rings one day and a male voice addresses me in Dutch, says his name is Bernard and that he got

my number from a friend, my heart leaps at the opportunity to talk with a man in my native tongue.

In the doorway I wait for Bernard and see him walking the long hall toward my apartment. The top of what seems like an enormous totem pole is decked with a crop of curly hair. Long legs lend a swagger to his walk. He looks like a bon vivant, but I notice that his face carries a serious, almost grave expression. As soon as he is aware of being watched, he looks at me with a questioning glance in his brown eyes.

With what seems like deliberate casualness, he saunters toward me, shakes my hand, follows me into the room, looks around and says, "U woont hier mooi." (You have a beautiful place.)

I invite him to sit down. Bernard stretches his legs under the coffee table, places an arm quasi-nonchalantly on the backrest of the sofa, and leans back. I study his hand. It is soft. The hand of a painter, a writer, or a thinker.

As our meeting stretches into hours, I study him in more detail and sense that all the ingredients for a romance are present: similarity of thinking, comparable experiences, corresponding reactions. We are especially well matched in our sense of humor. Last but not least, I am attracted to him.

Even though I feel excited, I know at the same time that this man will not be my mate. Wisdom and experience may be to my advantage, our age difference definitely not; he is many years younger than I. Besides, he smokes. Smoking is for me a greater deterrent to a relationship than age or appearance.

When Bernard leaves, he says he'd like to come back.

When we meet again, Bernard has brought a bottle of wine

for dinner. While I put food on the table and light the candles, he pours the Santa Isabella.

We talk, we laugh, we share our thoughts. Closeness, intimacy, romance are in the air.

I watch him eat his chicken. He licks his fingers with relish. I feel his sensuous manner of eating to the marrow of my bone and long to share more with him than food and drink. But he leaves me untouched.

A week later Bernard puts a bottle of champagne on the table. "This is a festive occasion," he announces and from the eager look in his eyes I know what he means.

We talk, banter, eat by candlelight and sip the champagne. Underneath it all burns the flame of desire. My proposal to lie down is met with enthusiasm.

Bernard is the first man in my life who is unable to enter me and who has no ejaculation either. He suffers, he admits, from "frequent impotence," especially after drinking alcohol. He is a caring man, though, who gives me great pleasure. But when I climax, the force of my voice disturbs him. Panic-stricken, he leaps to the open window and slams it shut. "I've never heard a woman carry on like that," he scolds in a sharp, punitive tone of voice.

Unspeakably embarrassed and ashamed, I silently resolve that this has been the first and the last time with Bernard.

Before he leaves, I say that we are not well-matched sexually and propose that we be friends. He says he'd like that very much, but I don't hear from him again. I am not motivated to reach out either and we don't see each other again.

Today is my birthday! Seventy. God, that sounds old! Should I prepare myself to live without a man? Give up touch altogether?

Lo and behold, the phone rings in the afternoon and the woman from Introduction Services cries exuberantly: "I've got a very special man for you. He just registered with us."

She informs me that he is sixty-five, bald, has blue eyes, is a teacher/writer, divorced twenty years ago. "He is a unique kind of man," she emphasizes. "That's why I thought of you. You are so unique yourself."

A compliment, I wonder, or is she trying to get two oddballs together?

A man with a slightly nasal voice phones, introduces himself as Peter and talks. I listen. He talks. I listen. But the listening is not filled with the boredom or exasperation I usually experience. This man has something to say. When he tells me that he took massage training, I can instantly picture myself lying down and receiving a massage instead of always giving one.

We decide to meet for lunch on Saturday.

On Thursday an ambulance takes me to the hospital's emergency room with what doctors think is a heart attack. In no time I'm wheeled to Intensive Care and hooked up to a maze of tubes and hoses.

The following day, my life still presumed to be in danger, I'm transferred to a private room with a telephone beside my bed. Frantically I call my children and tell them where they can find me. Then I call Peter to cancel our date. "Unless," I wager, "you wouldn't mind having our first date in a hospital room?"

A chuckle on the other end. "That would be a novel way of meeting. Why not? Where can I find you?"

On the agreed upon day Peter knocks on the door and comes in. Curiously my eyes take in his unusual appearance: bald-shaven head, khaki shirt, tanned arms with a down of gray-white hair, khaki shorts, bare, sun-tanned, well-formed legs, covered with curly short hair as well.

Bare feet in sandals walk towards the hospital bed. He bends forward and brings his face close to mine. A pair of twinkling blue eyes look at me and his lips fan into a smile. Cautiously bypassing the tubes protruding from my body, he gives me a gentle kiss on my cheek.

He pulls a chair close to the bed and begins to talk. I listen. He talks. I listen, grow weary and close my eyes.

"I should stop talking so much," he remarks perceptively.

"I would like that very much. Could we be quiet for a little while?"

"Of course! But allow me to touch you somewhere. It doesn't matter where. You tell me where I can hold you and we'll be quiet together."

I open my hand and hold it out to him. He takes it in one hand and cups the other over it. I close my eyes and relish the moment in which only the ticking of the heart monitor can be heard.

After a while, he strokes my arm softly and I hear him say: "I brought some almond oil to give you a massage. Would you like that?"

When I nod, he asks if I want my feet or my back done. Without hesitation I choose my back. Shyly I move my

nightie up, but the hoses of the intravenous and heart monitor are in the way. My new friend watches the struggle only for a moment. "Will you let me help you?"

I accept his offer, meanwhile trying to roll over as fast as I can to hide the scar on my belly. But under the circumstances that doesn't go too well. Here I am: leaning on my forearms, face and belly down, while the man, who was a stranger fifteen minutes ago, pushes my nightgown out of the way. My belly dangles above the bed sheet like a wrinkled banner. I lower myself, feeling unspeakably shy and exposed.

There is a trickle of oil on my back. With soft, slow strokes, Peter spreads the oil over my skin. Pressing gently, stroking, giving, caring, his hands glide over my back.

"Would you mind moving your panties down a bit?" he asks as though it is the most normal thing to do. "I'd like to include the lower part of your back as well."

I yield to his request.

His hands continue to stroke, slowly but firmly and without making one lascivious move. Quietly I enjoy this unexpected treat. When he is finished, words fall short to express what I feel and I offer him a kiss. His soft, full lips take in my offering fully, totally; my lips, my tongue and almost my dentures.

Carefully watching the intravenous needle, his hands stroke my hair, my arms. He kisses my neck, licks, sucks . . .

"Not too hard," I giggle. "I can't lie here with a hickey." We laugh and kiss again, I in wild abandon after my brush with death.

His hand slides under the sheets and rests on my breast.

"Can I hold you there?" he asks and, sensing my consent, he unbuttons the front of my nightie. As gentle as an undulating sea anemone, his hand covers my breast. At the feel of my nipple's response, Peter lifts his hand and looks at my breast. Then, with a mere flash of his blue eyes as if asking for permission, he draws me close. His tongue encircles the raised pink tip which rises and stiffens more. With soft sounds he sucks and licks my nipple, drawing the flesh around it up so deftly that I become young and ageless. Sighing, I arch my back and press all of me against him. Just as Peter's hands slide farther down, a startled nurse crashes into the room. "Are you all right?" she cries. "The monitor at the nurses' station went crazy. Your heartbeat seemed totally out of control."

Flushed and hot from kissing, I smile innocently and say that I feel fine. "Could something be wrong with the monitor?" I inquire coyly.

"Yes," she sighs, relieved. "That has happened before. Perhaps a tube in your arm got twisted."

"That might be the problem," I smile. "From now on I'll watch it."

As soon as the nurse has left the room, Peter's kisses resume. Elated to be alive I reciprocate with all my heart, but with one eye turned to the tube in my arm.

According to the doctors I'm out of danger, and I'm wheeled on a gurney from Intensive Care to a room with two other women. One woman of eighty-six is dying. The other vomits day and night and soils her bed. The room is filled with cries, stench and moans.

Peter visits me again. He appraises the new situation and with a resolute movement draws the curtains around my bed. It is strangely exciting to kiss each other secretly in that small, white cubicle. Life and death so close.

When I leave the hospital the cardiologist warns: "Even though it wasn't a major heart attack, we advise you to take it easy and to avoid all excitement."

To celebrate my homecoming, Peter arrives with a bottle of wine and orders in Chinese food. This is our first date outside of the hospital. Free and feather-light without tubes in my arms, I embrace him and draw him close.

With flowers on the table and candles alight, we enjoy the food, the wine and each other's presence. I look at my bald-headed friend who sits there so contentedly, his bare feet under my table as if he has always lived here.

The day has been hot and humid and the room is still warm. "Can I take off my clothes?" Peter asks after dinner.

"Of course! I told you before that I've been a nudist for years."

But he is not nude underneath his shorts. What hits my eye is a black leather jock strap encasing his penis. I am taken aback. Unaware of my reaction, Peter proudly turns around to show me the back of what he calls his "nifty outfit." I don't want to look at his bare buttocks split by a black leather strap that draws attention to the crevice.

Peter waits for my reaction. Too perplexed to comment, I secretly wonder why I feel so turned off. I had entertained romantic notions of a nude man who would longingly hold his arms out for me. But Peter prances around like a peacock,

admiring himself and wanting to be admired by me.

"It is obvious that this doesn't turn you on," he notices.

"Indeed it doesn't."

Without a trace of offense he remarks, "All right, I will take it off. But before I do, why don't you touch it to see how it feels?"

Guardedly I put my hand on the leather pouch and to my surprise the bulge underneath the soft leather feels more alluring than I'd imagined.

We lie down. In an effort to restore romanticism and to hide my wrinkles as well, I've turned off the light and lit candles. It is only in that soft merciful shine that I yet dare to be naked.

Gently Peter strokes my hair, my back, my hips and goes back to my head, twirls my hair around his fingers, kisses my ears, presses my body close to his.

I bathe in the luxury of his caresses. My breasts swell. With a firm grip Peter takes them into his mouth, kisses them one by one and sucks the warm flesh with a lusty mouth.

My hands trace the curves of his shoulders, his back, his hips, his penis, his thighs. I stroke the downy cover of hair on his arms, his chest, his belly, and legs. I explore the coat of curly hair around his cock and wind ringlets of hair around my finger. Peter has no erection.

I caress and touch his smooth, bald head, hold his face in my hands and kiss it, kiss his eyes, his nose, his mouth. My hands slide down again and take hold of his penis. Soft, flaccid and powerless it rests in the hollow of my hand. I bend down, take it in my mouth and do what the courtesan in me

loves to do.

"Let me kiss your titties again," he pleads and kisses my breasts, my belly, my navel and my half-shaven pussy; inheritance from my hospital stay. "Shave it all off," Peter suggests. "It is so much more sensuous." He takes hold of my knees and gently presses my legs open wider. His smooth-shaven head slides between my thighs and I feel the warmth of his tongue on my cunt, wet and hungry for more. My orgasm erupts like a volcano.

Soft music plays in the background. Candlelight dances around us. I cannot remember such joy.

Peter visits again, takes my head in his hands and kisses my lips. When we sit down he searches for my breasts. I wear a white lace bra that opens at the front. As soon as my blouse falls open Peter looks with relish at the two little mounds in the gauze-flowered envelope. "That's a pretty bra," he says endearingly. Gently, one by one, he strokes my breasts, kisses them fondly and lifts them from their meshed cage.

One day, when our playfulness has not given rise to an erection, I confess to Peter that I've begun to have doubts about my lovemaking skill. He explains that this has nothing to do with me. "You are a most sensuous and delightful lover. It's my diabetes. Many diabetic men have this problem."

He puts his arm around me. "But that does not prevent me from giving you pleasure and enjoying myself."

I snuggle up to him and say, "One thing is sure, with you I have reached the ultimate of passion. It is no longer I who take care of a man's pleasure, it is you who satisfies me time after time."

I am seventy-two now, and still with Peter. We talk, have meals together and lounge in his hot tub where he puts his arm around me as we watch the setting sun. Lovingly and without want I touch his wet body. Like a pearl in an oyster his penis lies, soft and weightless, in the water-filled palm of my hand.

At night his hand cups my breast and he presses me close. In his embrace lies all the endearment I yearned for.

We sleep the sleep of contented lovers.

About Dr. Eleanor Hamilton

*W*hen I grow up, I want to be like Dr. Eleanor "Ranger" Hamilton. Well, I guess no one will ever be exactly like her, but I wouldn't mind one bit if I could be as energetic, thoughtful, caring, creative and sexy as she is—and she is close to thirty years my senior! I was so pleased when she agreed to write the Foreword to this book, and I'm proud to dedicate it to her in acknowledgment of the inspiration she has been to me and to so many others.

Many readers will know little or nothing of this remarkable woman, so permit me to introduce her to you. I hope that these brief biographical notes will give you some insight into why I admire Ranger so much.

Years ago and years ahead of their time, Eleanor Hamilton and her husband, A. E. Hamilton, married in 1932 and pioneered an "open marriage," an inspired relationship which lasted for thirty-seven years until his death in 1969. Together they founded a progressive nursery school in New York City which drew the children of such interesting parents as Dr. Benjamin Spock, Governor Tom Dewey, violinist Yehudi Menuhin, the Rockefellers, and dancer Paul Draper. These and many others of equal achievement were drawn to the Hamilton Nursery School because they wanted a free-thinking and loving environment for their youngsters.

After her own four children were born, Ranger and her husband decided that New York City was not a place where

they wanted to raise their children. They turned their school over to Teachers College of Columbia University and moved to the countryside, where they founded a small boarding school for gifted youngsters who were having problems with the traditional schools of the time. For the next fifteen years they lived and worked with these extraordinary children.

Because of her interest in pregnancy, and her connection to so many physicians in New York, Ranger was often asked by the doctors to take unmarried pregnant girls into her warm and loving home. This prompted her to form the Maternal Care Adoption Center, which cared for each pregnant girl throughout her pregnancy, leaving open her option to keep the baby. They then helped her find a way to support herself and her child. If the young mother chose to give her baby up for adoption, she herself would select the kind of family she wanted her child to grow up in, and she was encouraged to meet with the prospective adoptive family. Although now this kind of open adoption is accepted and is becoming more common, in the 1960s it was considered outrageous and was illegal in many states.

These adoption practices were too radical for the times and Ranger was forced by the bureaucracies then existing in Massachusetts and Connecticut to give up her work in this arena. For the next fifteen years, she carried on an active marriage counseling and sex therapy practice in New York City, supporting her four children through college, and nursing her husband in his final years.

After her husband's death, she continued writing and counseling, and eventually learned a great deal about the life

and love of a widow, which led to her present occupation. For the past fifteen years, Ranger has written a regular column called "Living and Loving" (nearly 700 columns so far), on various aspects of love and sexuality, for the Point Reyes (California) *Light*, a Pulitzer Prize-winning weekly newspaper. And she is currently at work on a book about the "golden years" and how to make them truly interesting and exciting.

During her long and productive career, Ranger fought for the right of mothers to nurse their babies, and to give birth to them in the most humanized settings, settings that welcomed the presence of fathers at the birth of their children. She battled long and hard against what she calls the "cruel rite" of circumcising baby boys. And most importantly, in relation to the message of this book, she has always celebrated the many forms of love partnerships that truly express committed loving—however unconventional these relationships may be.

I salute you, Ranger Hamilton. Long may you wave.

—*Joani Blank*

About the Contributors

Anne Aiello (Youth is Wasted on the Young) is a nurturer and farmer. Her career has been in nursing with an emphasis on teaching. She has strong interests in music, and particularly in farming, where she enjoys planting and harvesting and tending to small animals. She finds links to her soul through both music and the land. She has grown children and looks forward to being a grandmother.

Tony Aiello (Senior Games) is a scientist, musician and athlete. His career has been in a scientific field and he particularly enjoys the process of discovery. He delights in the fact that the same ordered, structural relationships found in science are also found in musical harmonic relationships. As a singer/songwriter he finds links to his soul through his music. He greatly enjoys the role of grandfather.

Andrea Anderson (Getting Better All the Time) has lived in Central Europe, England and the United States. Her work experience includes homemaking, secretarial work, teaching and public relations. She has published numerous entertainment reviews, as well as articles on astrology and family experiences. Since childhood she has been an enthusiastic nature photographer. Suddenly widowed after a twenty-five year marriage, Andrea has two daughters and two college-age granddaughters. She enjoys classical music, reading, PBS, NPR, swimming, birdwatching and container gardening. While an early user of camcorders and VCRs, she eschews distracting

cell-phones and invasive e-mail.

Willie Baer (Still Growing) prefers that readers not know anything about him.

Fiona Blair (Knowledge is Power) is a free spirit/writer/ sexuality educator who lives on a dirt road in Vermont. One advantage of living in the woods is that only the bears and the 'coons are disturbed when she comes.

Sarah Breton (Follow Love's Path) is the oldest person contributing to this book. She is a psychotherapist and writer currently living in the Northwest with her rambunctious dog and hundreds of books.

Doug Campbell (Through the Jungle) was born at his grandparents' home in a village among small farms and orchards in Ontario, Canada. He emigrated to the U.S. with his parents when he was nine. In 1941 Doug declared himself a conscientious objector to military service, and spent four years in alternative service work. In this program he met others working for a peaceful and sustainable world, and became a more aware and fully committed pacifist. Toward the end of the four years of service, he met an Antioch College woman who also had become a thorough pacifist. They were married, raised six children, and celebrated their fiftieth anniversary in 1996.

Whether welding metal sculptures, cartooning, or writing, *Lyn Chevli* (Celibate) has chosen dynamic sexuality as the subject matter for most of her work. She is the author (under the pseudonym Edna MacBrayne) of *Alida: an Erotic Novel* and this is her third short piece published by Down There Press. She is also half of the duo who created the underground comics series "Tits & Clits." At sixty-eight, she is still

ravishingly beautiful, her talent is undimmed, and she is working on her second memoir. Her only flaw is flamboyant overuse of hyperbole.

Helen Davis (Retired) is the eldest of three siblings. Her father was a Unitarian minister and her mother was a school teacher. Her childhood was spent in Chicago, her teenage years in Massachusetts. After two years of college, Helen accompanied her family to South America. She traveled to Europe where she married a European. They moved to Colorado were they both continued their education and had four children. Helen graduated with a Master of Social Work and worked as a social worker until she retired. She has been married twice–the first marriage lasted twenty-one years, the second seventeen. She and her current partner Fred have been together almost two years. It took her sixty-five years to figure out what she really wanted in a mate.

Joe De La Torre (In Limbo) was born to Cuban parents on a ship with French registry halfway between France and Cuba. He studied fashion design in Florida and later moved to New York City where he worked in movie entertainment and continues to live today. He has survived prostate cancer and helps others with the same illness cope with the problems associated with it. If he could live his life all over would he change it? Doubtful. He has lived the "best of two worlds" and says he has loved every minute of it.

Bruce Eastwood (Seasonal Changes) is a veteran of the Korean conflict. After his discharge he completed his Bachelor of Science degree and worked as an investigator for the federal government. He resigned his position after four years to

earn a master's degree. He then spent ten years as a minister, leaving that profession to become a college professor. He is now an Emeritus Professor and is enjoying his retirement.

Margaret Evans (Single by Choice) is a native San Franciscan, lives in a wonderful house surrounded by trees and flowers and enjoys all that life offers. She has her down days but usually bounces back well. She enjoys her amazing family (especially her new grandchild), her work, and the company of both sexual and platonic friends. Her time alone is also very precious to her. As author May Sarton says, "In solitude we are never alone."

Richard Flowers (Never Too Late) was born in 1928 into a well-off and stable family. His mother died when he was four, and his stepmother was never able to take her place. After an expensive education, he did two and a half years of National Service, and then became a farmer. He went back to school in his forties, and became qualified to teach. He taught math in high school for ten years, while continuing to farm on a reduced scale. A minor heart problem showed up when he was in his early fifties, and he took early retirement at the age of fifty-five. He left his marriage, relocated, and completely changed his lifestyle. The heart problem had disappeared when his story begins.

Stuart Greene (A Ruling Passion) has sex with his adoring and adorable wife Kim at least five or six times a week. He considers himself an expert pussy eater, and Kim concurs. Giving pleasure to both women and men is his greatest pleasure. He and Kim have an "ethically non-monogamous" relationship which includes a number of special sexual

friends, small and large sex parties, and the occasional "date" with others. He is now a sexy sixty-four years old, and continues to explore new sexual and emotional frontiers. He's experienced years of loving and growing, heartache and joy, and he believes that whatever comes next is just one more wonderful adventure.

Jim Hall (Submission) is a sixty-three year old retired man who lives with his wife of forty-one years. He enjoys watching football on TV and reading fiction books on World War II.

Doug Harrison (Thwarted ResErection) is an active member of the San Francisco leather community and a "modern primitive." He identifies as a bisexual switch, and leads workshops and retreats dealing with the spiritual aspects of consensual s/m. Doug's writing includes reviews, essays, and short stories that have appeared in *Black Sheets, Body Play,* and the anthology *Men Seeking Men.* He is currently working on a book on erotic whipping to be published by Daedalus Publishing Company. Doug was Mr. June for the San Francisco AIDS Emergency Fund's 1999 South of Market Bare Chest Calendar. He also appears in porn videos.

Beth Hartman (Staying Alive) is a devoted mother and grandmother. She jogs and occasionally runs in races. She's a librarian and a volunteer literacy teacher. She is active in opposing capital punishment, loves films, hiking and art museums. She has been married only once. Her last publication, almost twenty years ago, was an article about wildflowers in a horticulture magazine.

James Kane (Swingin' Seventies) has been in public relations for nearly forty years. He taught marketing at a

prestigious East Coast university and wrote extensively for a major newspaper. He holds a master's degree in fine arts, is an accomplished watercolorist and plays five musical instruments. At seventy, he considers his last two years the best he's ever enjoyed thanks to Viagra and the spurt of sexual energy shared by him and his wife of forty-five years. He says that he feels a bit like the old oak tree that starts dropping many acorns just before it dies. This increased interest in sex may be nature's final burst of glory. And they thank God for it.

Josephine Kay (Party Girl) was married at eighteen and was just forty-eight when her husband died in 1977; her sons were just twelve and seventeen. That same year she had a double mastectomy for breast cancer. She has a master's degree in human sexuality, and certificates in massage and HIV prevention education. Just as she began to explore new sexual options, the threat of HIV loomed large. Shortly before she turned sixty, Josephine and some friends started holding masturbation parties.

Chuck Kennedy (Clean Old Man) was born in Pittsburgh, Pennsylvania, in 1926. After World War II and the Korean War he vowed he would surprise someone every day. He invented Weird Tales art in the '50s, creating thousands of depth dioramas all over the West, and miniatures now in the collections of many celebrities. Volunteering art and time in senior housing and VA AIDS wards, he has proclamations from San Francisco mayors, and a North Beach banquet room named in his honor. Recently he's been studying hieroglyphics, has received his first driver's license, designed a computer game, and performed stand-up comedy. He is cur-

rently doing water aerobics and weight training.

Freya Lang (The Personals) is a retired academic who smells the roses and watches whales from her home in northern California. Once a prolific author of textbooks, she now writes non-fiction short stories and is at work on a novel. Since writing the story of her adventures with the Personals in New York City, she has become somewhat more circumspect, slightly less horny.

Daniel Larsen (Such Sweet Suffering) after squandering opportunities to graduate with honors from college, worked as a warehouseman, gardener, truck driver, photographer, and book editor before finding shelter in the calmer waters of public relations, where he still works. He and his wife of many years live in California and have two grown children. He is an avid sailor and runner, and enjoys poetry, wine, gardening and classical music as well as Sunday afternoon football. His greatest dream is to buy Marlon Brando's South Pacific island and sail away.

Annie Maine (Keeping Sex Alive) has always loved sex because when one is having sex, one is holding or being held by another "one." She believes this human contact is vital for the health of the soul, and growing old should not preclude it. An aging body is like an old house: a little worn on the outside, but super comfortable on the inside. She has three great children, a 100-acre home in New England, and an interesting range of past lovers: a famous film director, a labor lawyer, an artist, a carpenter, a printer, a mill worker and a window installer. Besides making love, Annie Maine writes, acts, directs, fiddles, dances, and swims.

Thomas Matola (Stroke) is a psychologist, sexologist and teacher. He had a major stroke in 1991. Still recovering, he now spends his professional time lecturing and writing in the field of sexuality, disability and aging. He is an activist in the disability rights movement. Tom studied with Stan Dale and at the Human Awareness Institute. He did his graduate work at Long Island University and at the Institute for Advanced Study of Human Sexuality. Tom's creed is to keep moving and doing with life what is meant to be done. Live It and Love It!

Louise Meadows (Twilight with Leo) enjoyed her first sexual experience with two older girls at the age of four. A few years later, she became a professional tap dancer, performing in several 1930s Warner Bros. kiddie shorts. At Barnard she shocked her fellow English students with an explicit sex story about the murder of a little boy by two older girls. Her story was later turned into a screenplay and selected by San Francisco State University cinema students to be made into a film. Louise worked for ten years as a copy editor for a progressive newspaper. She presently contributes to men's magazines.

Helen Michaels (Spice) was born in Cambridge, Massachusetts, in the early 1930s to below middle class parents. Having had rheumatic fever as a child and parents unable to take care of her and pay her medical bills, she became a ward of the state. She graduated from high school at age eighteen, married at nineteen, had three children by age twenty-four, and was divorced after thirty unhappy and lonely years. Then she experienced liberation—physically, emotionally and sexually.

For many years she worked for the telephone company. She now resides in upstate New York, has a delicious male friend and is living happily ever after.

Bill Noble (Lazarus) is a California writer and poet. A realistic acquaintance with mortality has, he hopes, made him wiser, more tolerant, and maybe even sexier. What's sex, after all, but a graceful, caring acknowledgment of our essential solitariness and our immersion in the generations of our kind? Things don't always get better, he knows, but right now, they do, they do.

John Oldman (Sex After Sixty) was born and raised in New England. After graduate school in Oregon he was a professor in Nebraska, retiring at age sixty-two. Twice divorced, he now lives with Vicki south of San Francisco. They are closer than either dreamed possible, having become each other's best friend, spiritual partner, ardent lover and trusted confidant. Trying to write fiction since retirement, John remains determined to turn out just one simple declarative sentence before going on to more worthwhile pursuits.

Robert Perham (Among Friends) is the real name of an actor who is known to all but his family and a few close friends by his pseudonym. At eighteen he was at Omaha Beach in Normandy on D-Day. He has fathered three children, has lived on both coasts and in Hawaii, and has appeared on Broadway in numerous TV series and in fifteen feature films. He has been active in women's liberation, has worked with the National Sex Forum, and has starred in two educational sex films.

Sal Pine and Al Pine (Satisfied) now seventy-four, met in their early fifties. From about age eight masturbation was im-

portant to Al, and when he was a merchant marine, "girls of the night" pleasured him. Al's gift to Sal of Betty Dodson's sensual sketches and the manuscript for her book *Liberating Masturbation* (1972) was Sal's introduction to pleasuring herself with the Hitachi vibrator. She was free to fly! In the late '70s, Sal and Al hosted swinging gatherings in their Bay Area home which helped bond their mating into marriage. Pleasuring each other and themselves they continue life's journey erotically.

Sylvana Simonette (My Night with Zorba) recently retired to become a writer. Previously she had worked as a clinical psychologist and as a Peace Corps researcher and teacher. Her numerous publications and a book in progress reflect her multi-cultural background and international experience. Born in Mexico of French parents, she has lived in Cuba, the United States and Brazil. Equally important, her writing reveals her voyage into the deep understanding of the minds and hearts of people. Dr. Simonette lives in Woodstock, New York, with her cat Chico.

Caroline Smilley (Toys for Grownups) was born in Chicago in 1936. She was raised by her mom and dad, and had one sister with whom she always shared a bedroom. Family life was very serene. The girls were brought up Catholic and went to church every Sunday. They attended public schools, were good students and never got into any trouble. She really regrets never attending college. She's been married for forty-three years to her childhood sweetheart who treats her wonderfully. She's going through a little bad time now with cancer—but she's a fighter and she'll try to beat it.

Born in Amsterdam and educated in Speech Pathology in the Netherlands, *Lin Stevens* (Vintage Sex) emigrated to Canada in 1979. After raising her three children, she worked for the Ministry of Health as a speech and language pathologist for ten years. She took additional training in psychotherapy, moved back to Holland and started a pracrice in Gestalt therapy and Reichian bodywork in Amsterdam. A three-month journey to an ashram in India convinced her that enlightenment was not to be found there. Her experiences were published as a book in 1979. She wrote three more books in Dutch, returned to Canada and now lives there permanently, still writing and still interested in the art of making love.

Rusty Summers (Sparkle) was born and raised in the Midwest. He had a career in the military, including fighting in World War II. A marriage of twenty-six years produced one child and ended in divorce. That was followed by two long loving relationships, the first of which ended amicably and the second of which is still underway.

About Joani Blank

JOANI BLANK worked as a sex therapist and sex educator starting in the early 1970s. She taught human sexuality at the community college level, led sexuality workshops for women, and was an active volunteer and trainer at San Francisco Sex Information.

In the spring of 1975 she started Down There Press with the publication of *The Playbook for Women About Sex*. Down There Press now publishes the work of other authors as well, and boasts a list of a nearly twenty titles.

In 1976 Joani published the first edition of *Good Vibrations*. She opened her retail store, also called Good Vibrations®, in the same year so that women would have a comfortable and non-threatening environment in which to learn about and buy sex toys and books.

The store and subsequent creation of a mail order catalog also provided an outlet for her books. In 1988 she started The Sexuality Library, a catalog of sexual self-awareness and enhancement books.

In 1992, Joani and her employees reorganized the growing company as a worker-owned cooperative. She is now recognized as Founder and Publisher Emerita, while continuing to promote the business, pursue her interests in cohousing and community economic development, and to enjoy her grandchildren.

When Joani turned 60 in 1997, she began to consider the

implications of sex with aging, and began looking for others "of a certain age" to write about their sexual experiences in their sixties, seventies, eighties—and even nineties.

Joani is a graduate of Oberlin College and received her MPH (in Public Health Education) from the University of North Carolina at Chapel Hill.

ɞ

Other Books by Joani Blank

A Kid's First Book About Sex

The Playbook for Kids About Sex

The Playbook for Men About Sex

The Playbook for Women About Sex

Femalia (editor)

First Person Sexual: Women & Men Write About Self-Pleasuring (editor)

Good Vibrations: The New Complete Guide to Vibrators (with Ann Whidden)

Herotica 2 (co-editor, with Susie Bright, NAL/PLUME)

I Am My Lover: Women Pleasure Themselves (editor)